MARKET
THE SELLERS | THE STUFF | THE SOUL

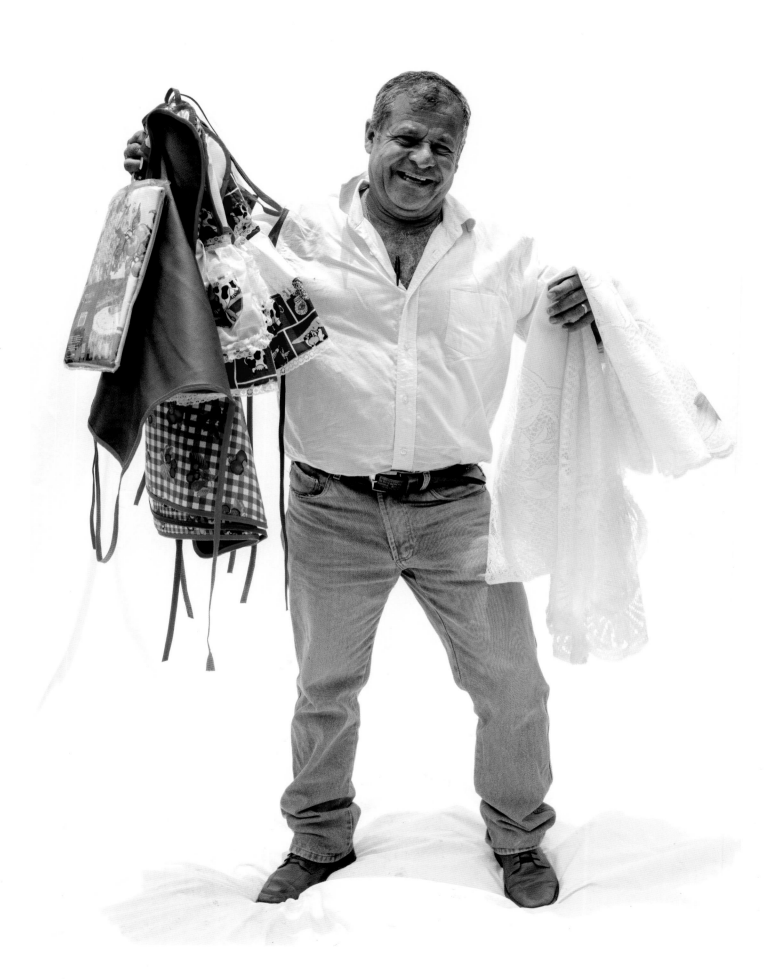

To the Heron Point Community: We are glad to join you. I hope you will enjoy this journey.

Neal Jackson

2/14/2020

MARKET
THE SELLERS | THE STUFF | THE SOUL

Portraits from the World's Meeting Place

NEAL JACKSON
Foreword by Maggie Steber

Published by Worldinsight Media

(left) Remigio Sierra | cloth items | Mongui, Colombia

This book is dedicated to
my extraordinary wife, Sandra Willett Jackson.

From its inception she supported this project
with enthusiasm, travelled to many of the markets with me,
and in many of them played a major role in the
recruitment of vendors. Her visual observations and
recommendations in the book production were invaluable.
What an eye…. I could never have completed
this project without her.

Merci mille fois, ma petite puce!

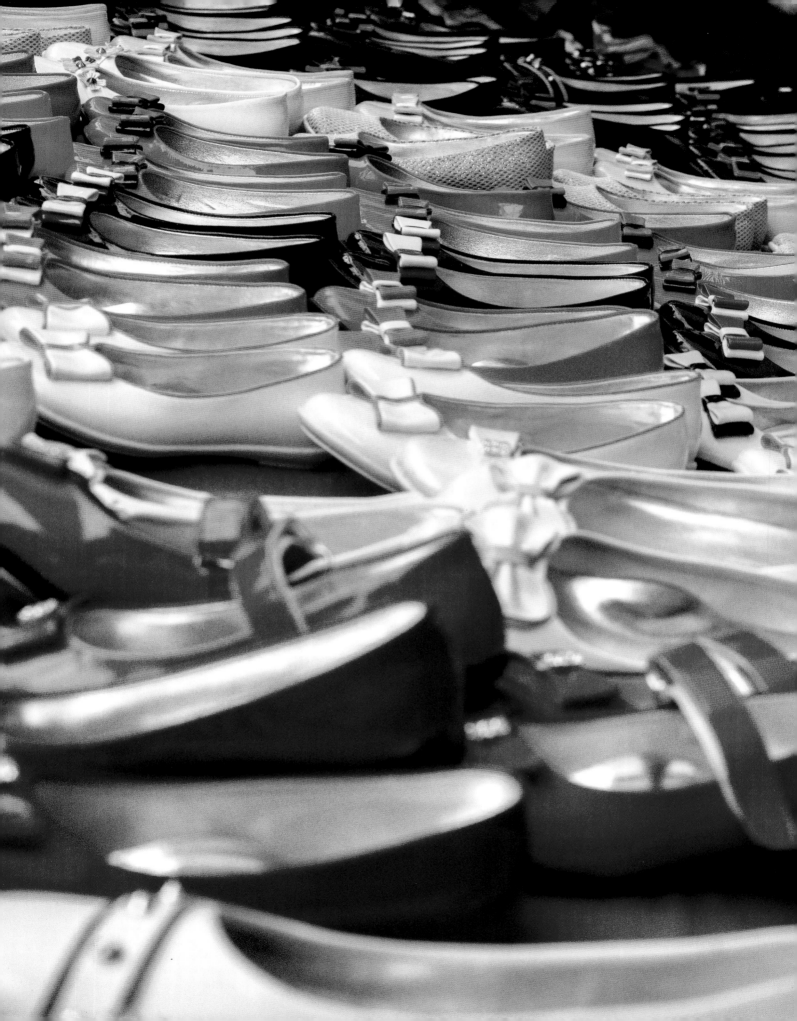

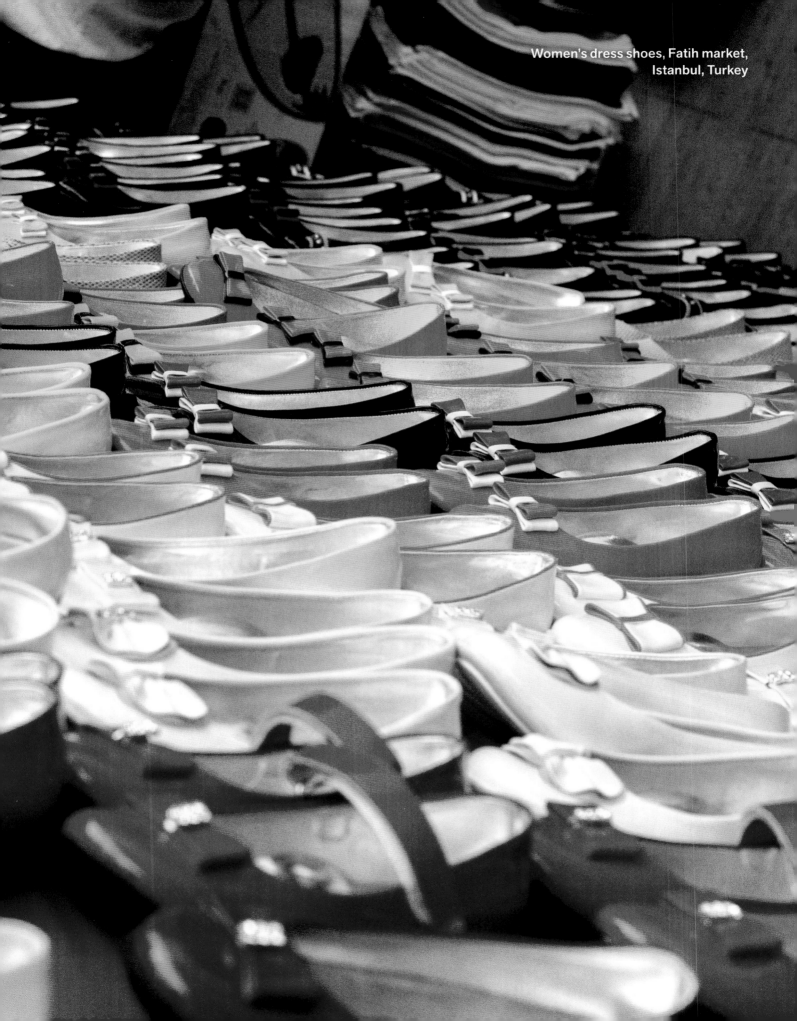

Women's dress shoes, Fatih market,
Istanbul, Turkey

Tushnee Saita | chickens | Chiang Mai (Avitha market), Thailand

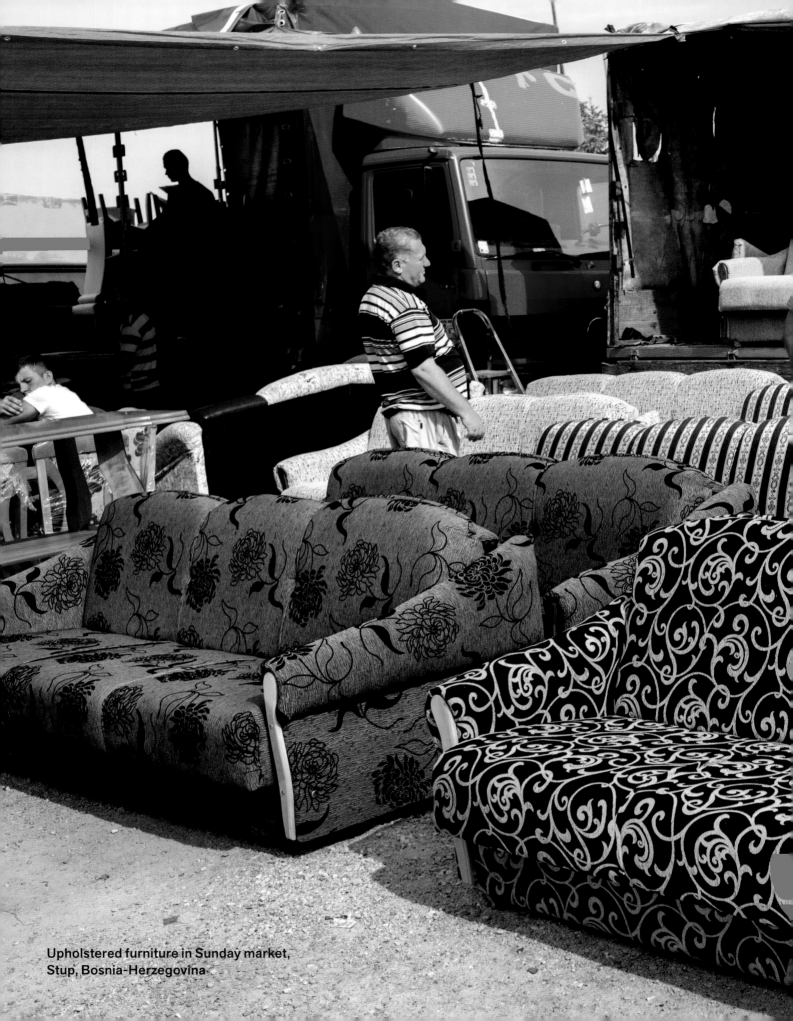

Upholstered furniture in Sunday market,
Stup, Bosnia-Herzegovina

Msondezi Kolise | handmade metal products | Cape Town (Langa Township market), South Africa

Used hand tools in Sunday market,
Stup, Bosnia-Herzegovina

Foreword | By Maggie Steber

Once a year before the beginning of the school year, my mother would take me to the high-end family-owned department store downtown and give me her credit card. "You may spend $200 for school clothes," she instructed and dropped me off for the afternoon. That was some kind of trust for a 13-year-old. I took my time getting to the clothing department, preferring instead to meander for hours throughout the store, lingering over assortments of scarves and candy, perfume and odd little kitchen utensils that looked like toys that might come to life at night, beautiful fabrics and hats and gloves and things that young girls dreamt of having when they became grown women.

However, the best part of this annual adventure was the older women who had made a career of serving the needs of others. Even though I went but once a year, they always remembered me and would greet me, even showing me things they knew I wasn't there to purchase. Genteel and polite, they always served me with a smile and some funny stories. They were very correct and treated me as though I were a proper lady there to shop.

In my work as an adult, I have had the good fortune to travel extensively, discovering the treasures of public markets in 67 countries. These markets are a world unto themselves. Like those unforgettable ladies in the department stores, the merchants who sell their wares are charming, coaxing, convincing, and generous.

My friend, photographer Neal Jackson, shares this same fascination with the global world of public markets. With his brilliant portraits of merchants and the treasures they sell, Neal carries us on a flying carpet into this magical world. In this book art and commerce come together in an intimate presentation that we rarely associate with shopping. We meet merchants who proudly offer their wares from a myriad of countries and cultures, and they become our instant friends.

In the photographs they are brought to life with a joyous spirit in a rainbow collection of the most exotic assortment of items: camels from Qatar, cattle from Columbia, shoes from Turkey, couches from Bosnia-Herzegovina, foie gras and wine from France, bananas from Ecuador, wedding accessories from India. We are reminded of the variety of things people consume, eat, wear, ride,

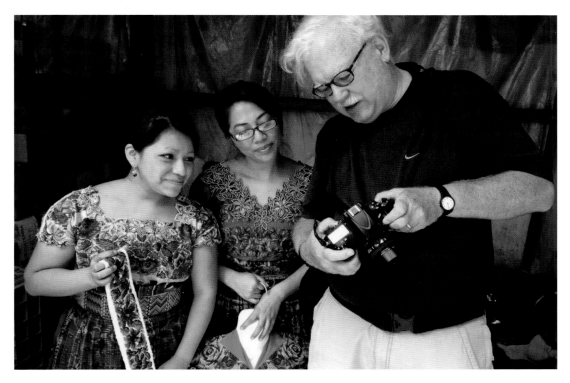

Neal Jackson sharing preliminary images with vendors in market at Chimaltenango, Guatemala
Photo by Ana Maria Buitron

and desire all over the world. We are treated in this joyful assortment of goods and people to the universal experience of culture and community.

Yet these photographs take us far beyond the exchange of money for goods. The portraits reflect human experience and its history. They come from something or someplace we often forget to honor in one another: the creative spirit of humanity and celebration of life.

This is first-person shopping, celebrating markets that spring up to serve the specific and general needs of communities. There is the thrill of the fresh open air, the real-life exchanges between people that make traveling vivid and enlightening. This is not tee-shirts being sold in a tourist store or trinkets that end up in the attic. This is the real deal. The photographs become a visual shopping list for travelers going to familiar and far off exotic places, a compendium of what mankind has wrought.

But it's the portraits of the merchants, their personalities, smiles, and obvious joy of showing off their wares that move us the most. What Neal shares with us in his photographs is the stuff of dreams.

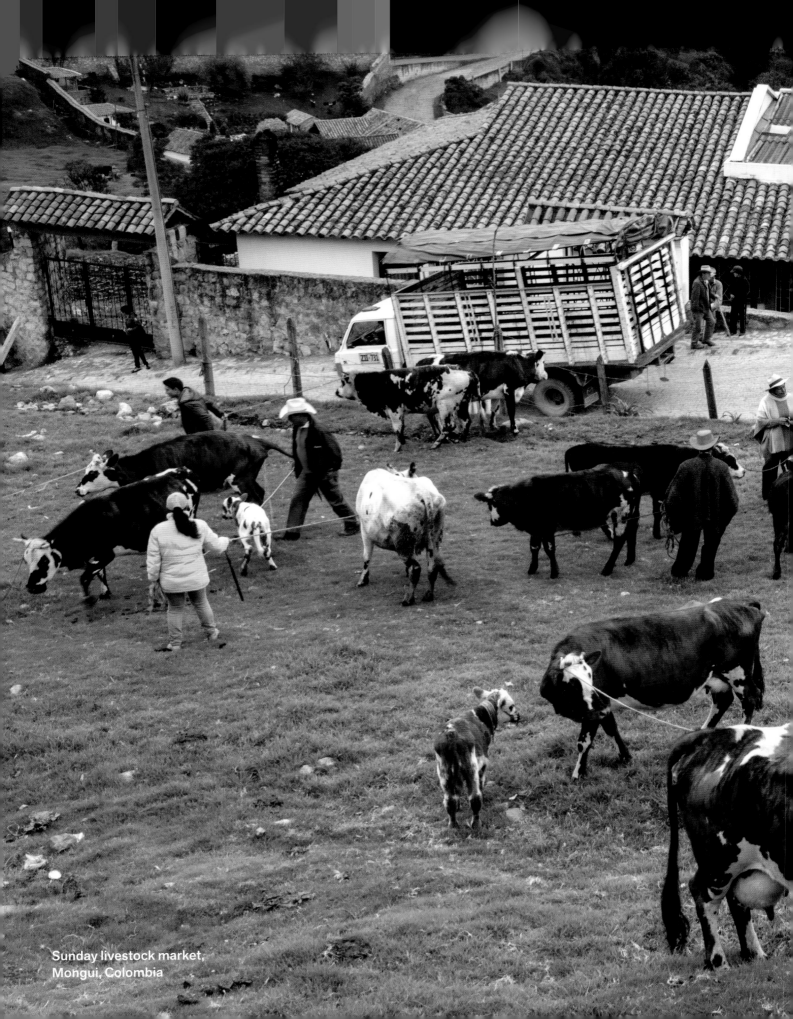

Sunday livestock market,
Mongui, Colombia

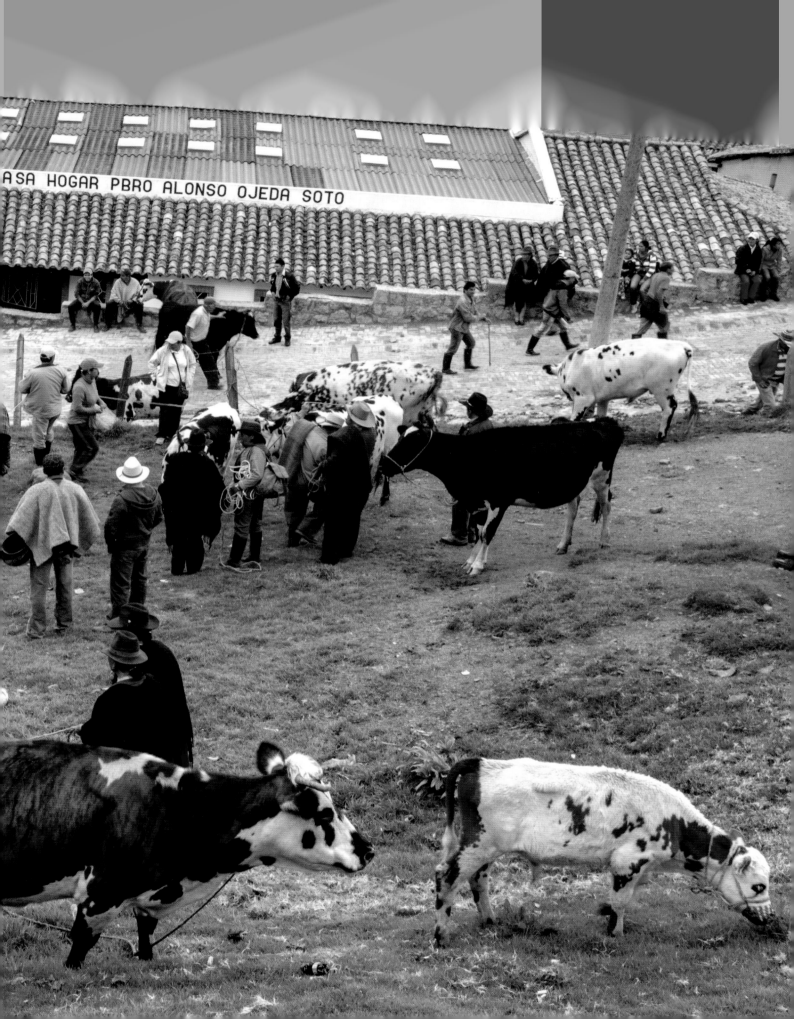

Introduction

O n a typical Saturday or Sunday near Mebane, North Carolina, the open-air market known as Buckhorn Flea Market is filled with hundreds of people buying clothing, seafood, vegetables, household goods, even pets and livestock. Buckhorn, a massive institution catering to the regional Latino community, prospers despite the presence of a Wal-Mart store less than four miles from it.

It has been said that traditional public markets in developing countries make up as much as half of the total value of those nations' household commerce – food, clothing, cleaning supplies, even some building materials and hardware. The markets often employ, at least on a part-time basis, sizeable portions of the local populace (some two-thirds in one Moroccan city studied). They also provide opportunities for entrepreneurial activity in the community. The cost of entry is low, and the marketing expense is minimal.

Even in developed countries, the economic activity of public markets can be significant. Ten years ago in the state of Florida alone, sales at flea markets were some $170 million per month. That translates into over $2 billion a year, and that's just one segment of the Florida public marketplace (farmers' markets have grown exponentially since then).

But the economic impact of such markets wasn't what drew me to them. Rather, it was their place in their local communities. As I went from one to another I realized that each has a personality, an

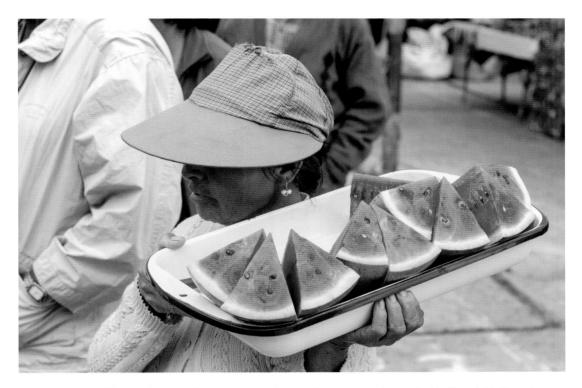

Woman selling melon snacks among vendors and customers in market in Saquisili, Ecuador

atmosphere, a *leitmotiv*. Some are governmentally organized, some are made available by private entrepreneurs, some are sponsored by local NGOs, and some just seem to have sprung up in a particular open place, maybe hundreds of years ago. Some are retail outlets; others sell to both retail and wholesale customers. But even with these differences, all had stories to tell.

But how do you tell their stories in pictures? Sure, many of us have taken colorful pictures of vegetables, meats, and other goods being sold in public markets. But those images do not fully capture the essence of a market.

After pondering the subject I concluded that the markets were really defined by their vendors. The vendors' personalities, connections, particular goods, cries to customers, and even the twinkle in their eyes, combined to create a market's atmosphere. To capture these vendors' essence I decided to take standing portraits of them and their goods in their markets. To equalize the visual paradigm I decided to take the images in the markets in front of the same white backdrop in the natural light in the market.

This proved to be a challenge. Markets are often terribly crowded. Finding a place to set up a three-meter square backdrop was not easy. Wind was often a problem, as was rain. Getting vendors to the makeshift "studio" required careful coordination because they were busy and often had little or no help to watch their goods if they left. Light was always a problem, but I was committed to use

natural light only. In some cultures vendors wanted payment, but as a photojournalist I could not ethically pay for images (no vendors photographed in this book were paid). Others were reluctant to allow their photo to be taken out of fear that it would fall into the hands of their government, which would use it for improper purposes.

Nonetheless, in the five years I worked on this project, I was able to capture thousands of images of hundreds of vendors, located on every continent but two (Australia and Antarctica – the latter has no open air markets!). I traveled to 26 countries, and in some countries, to multiple markets.

One significant thing I learned was that, from country to country, the markets were more similar than different. Sure, in countries where there was little refrigeration chickens were sold live, while in others with refrigeration more widespread they were sold dressed out. But everywhere vendors were fully plugged into their clientele's needs and expectations. Bargaining was often vigorous, but when a deal was struck, there were no discernible hard feelings.

And, most important, the market was more than an economic engine or source of goods. At the market people connected with their friends, exchanged community information and gossip, and passed along political and social messages. Youth of marriageable age encountered one another. The market was always a key institution that helped knit together a community – a town, a neighbor-hood, a region, a tribe.

Only in one city did things fall apart. I arrived in December 2013 in Kiev, Ukraine, and a snowstorm began the morning I was to begin photographing in the markets. But more important, the Maidan demonstrations – which led to the Ukraine revolution two months later – were in full swing. The city's atmosphere was charged with anxiety, and people in all areas were unsure of the direction matters might take. The social perceptions dramatically changed the markets' vibe and the vendors' willing-ness to participate. Because of that there were to be no market photographs from Kiev.

I was honored to have been so welcomed in the markets around the world. In some markets by the time I left I was in effect an honorary member, with vendors insisting we try their goods for free. Vendors told me about their personal lives and aspirations and trusted me enough to sign releases (always presented in the local language) for their images to be identified and used.

As in so many photographic ventures, many fine images did not make it through the editing process. Yet I think the ones selected convey the diversity – and the similarity – of this vital world institution. I hope you will enjoy the portraits of these people who make their communities thrive.

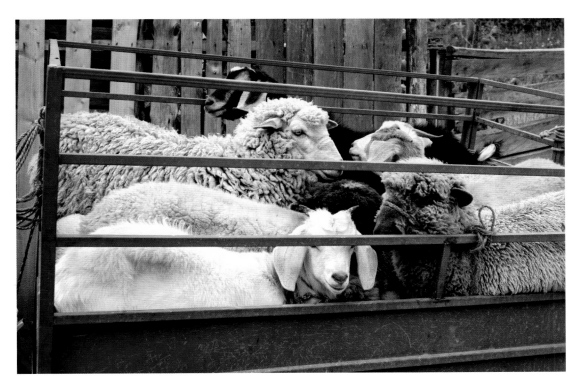

Sheep and goats in livestock trailer in Mongui, Colombia

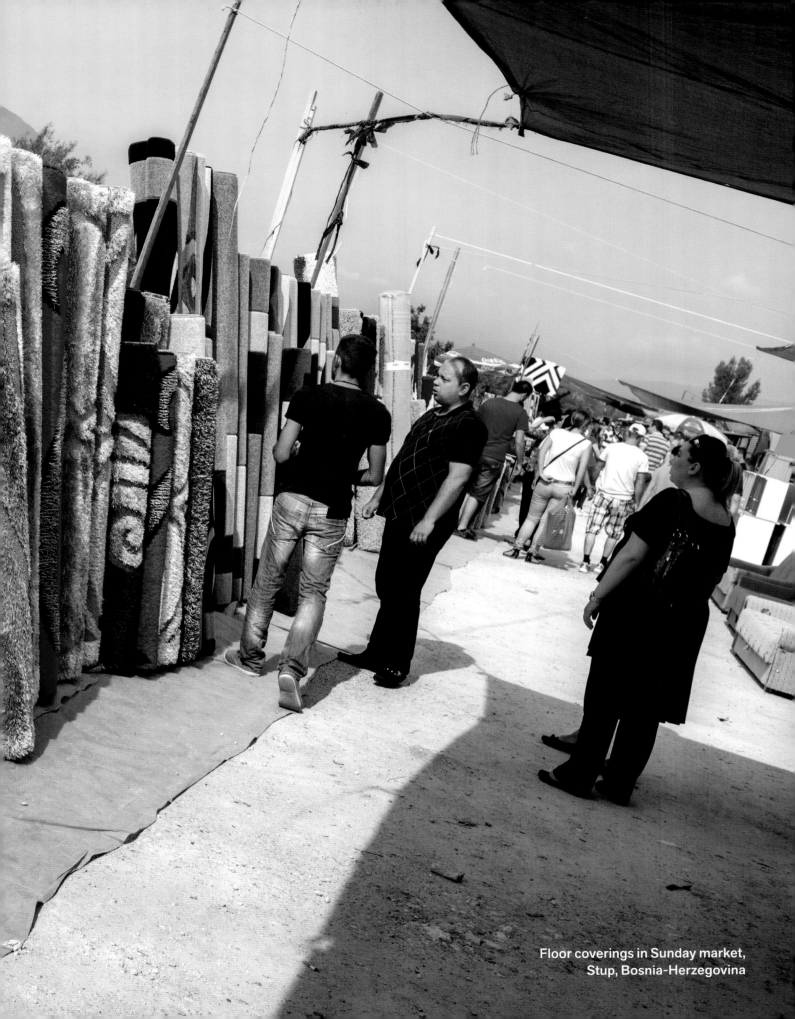

Floor coverings in Sunday market,
Stup, Bosnia-Herzegovina

Anomalies popped up in nearly every market. In Bogota we discovered a huge inventory of clay pots. When we asked the knot of women (preteens to greyheads) who appeared to be running the place for someone to pose for a portrait, there was a quick babble, one ducked behind a stack of pots, and out came Jose. He was clearly the boss of the operation, and he seemed very comfortable wearing his suit, which apparently was business as usual.

Jose Antonio Piuilla | clay pots | Bogota (Central market), Colombia

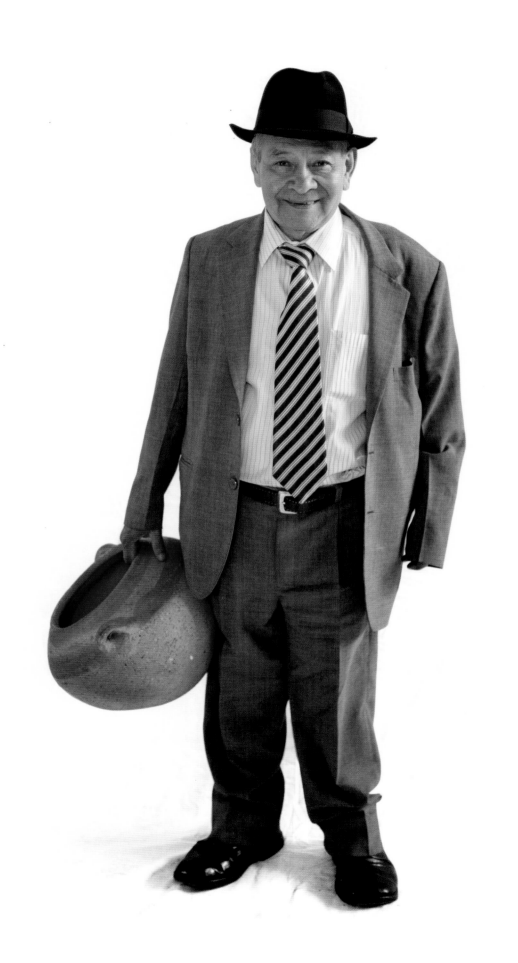

Muammer Kaynar | curtains | Istanbul (Fatih market), Turkey

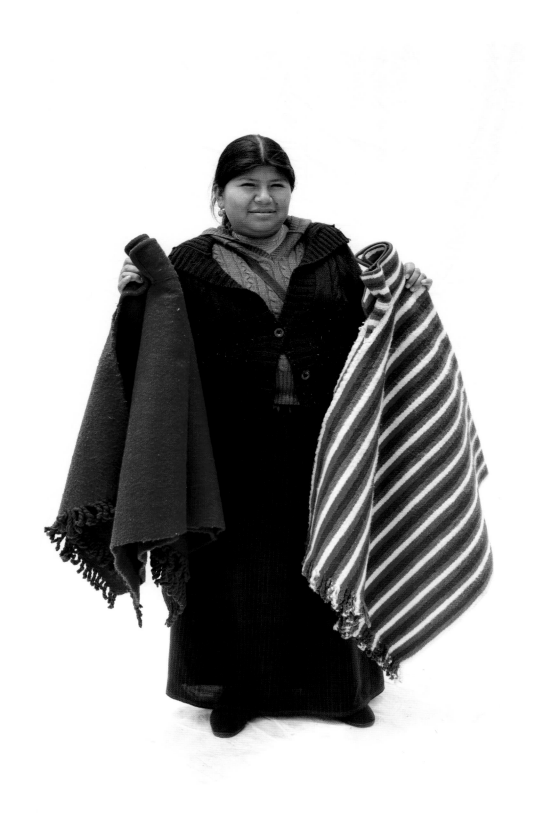

Blanca Morales | ponchos | Saquisili, Ecuador

Umesh Kumar | cooking oil | Pataudi (Nauhata Chowk market), India

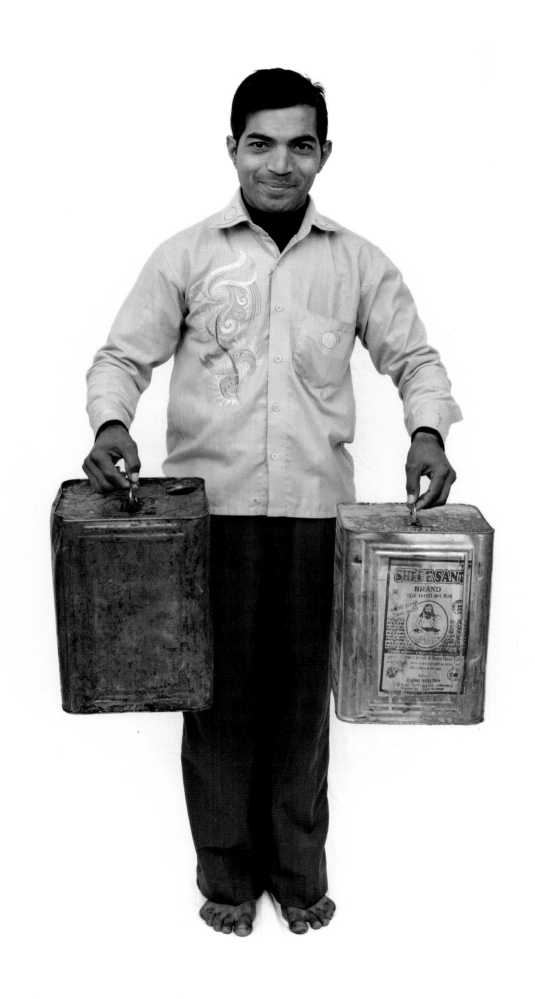

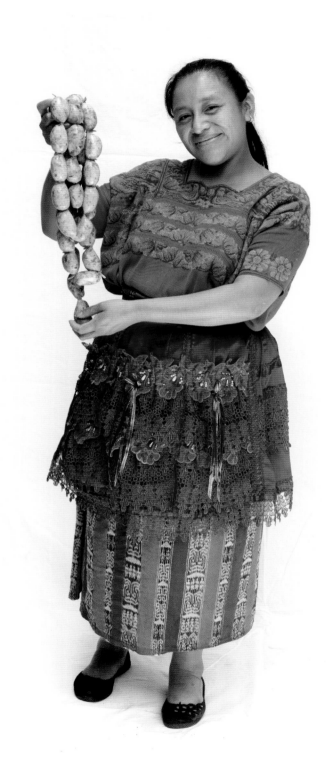

Victoria Tol | sausages | Chimaltenango, Guatemala

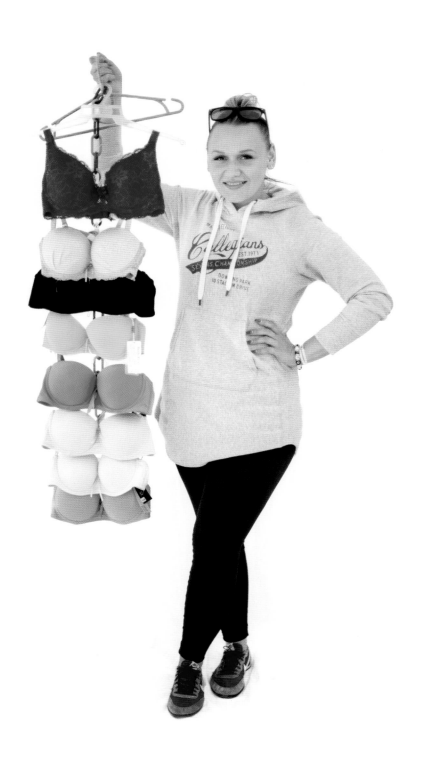

Kowalska Katarzyna | underwear | Warsaw, Poland

Akbar Malik | bedding | Pataudi, (Nauhata Chowk market), India

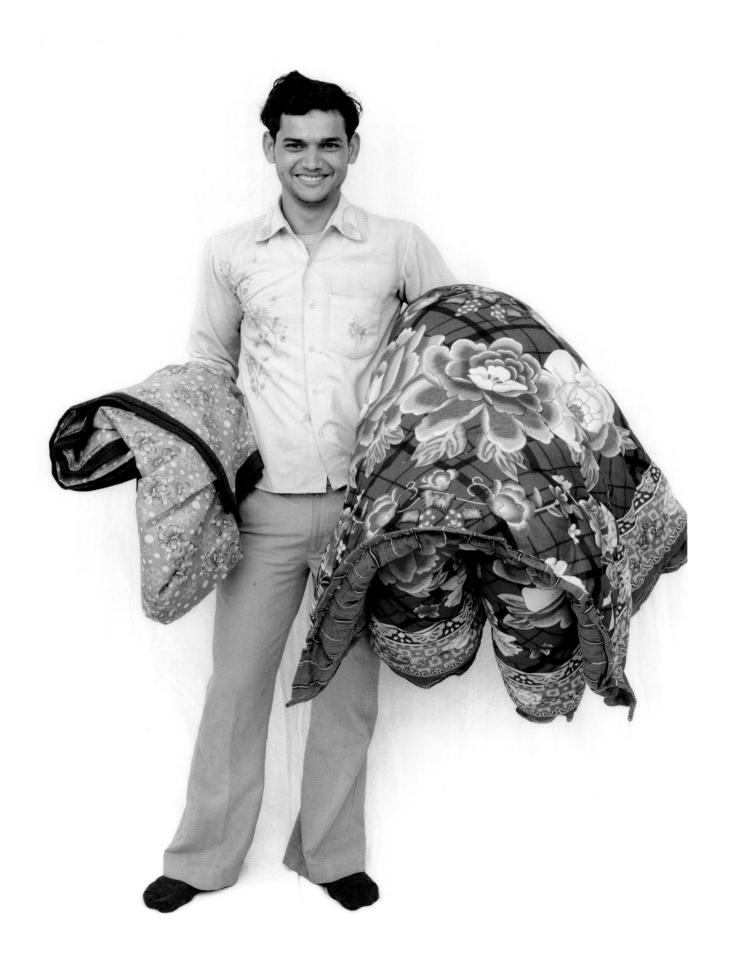

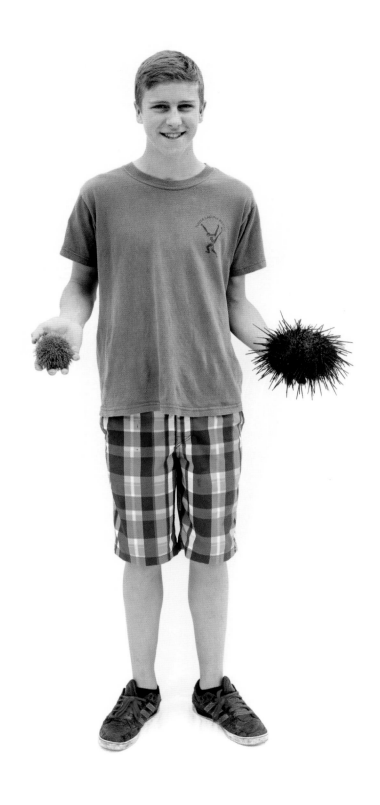

Connor Lindsay | sea urchins | Steveston, British Columbia (Steveston Landing market), Canada

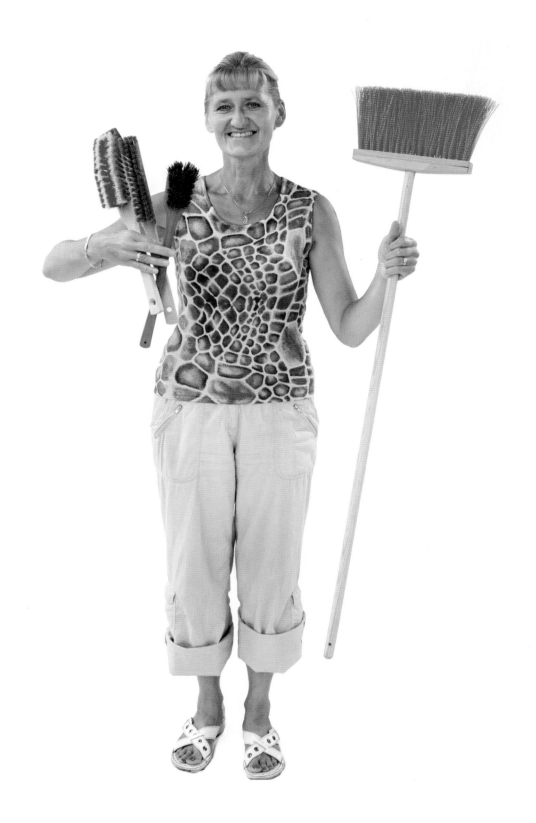

Elzbieta Sokolska | brushes and brooms | Warsaw, Poland

Dealers in the Doha camel market (all from Sudan, I was told) were warm and cooperative. Their inventory, however, was considerably less so. Moving a massive beast so most of it was in front of a three-meter square backdrop was no easy task. The camel we selected was especially cranky, and at one point seemed to be building ammunition to spit at me. In the end, it settled down and we got the image, but as he left we were presented with a pile of pellets…

Youssef Said Mohammed | camels | Doha (camel market), Qatar

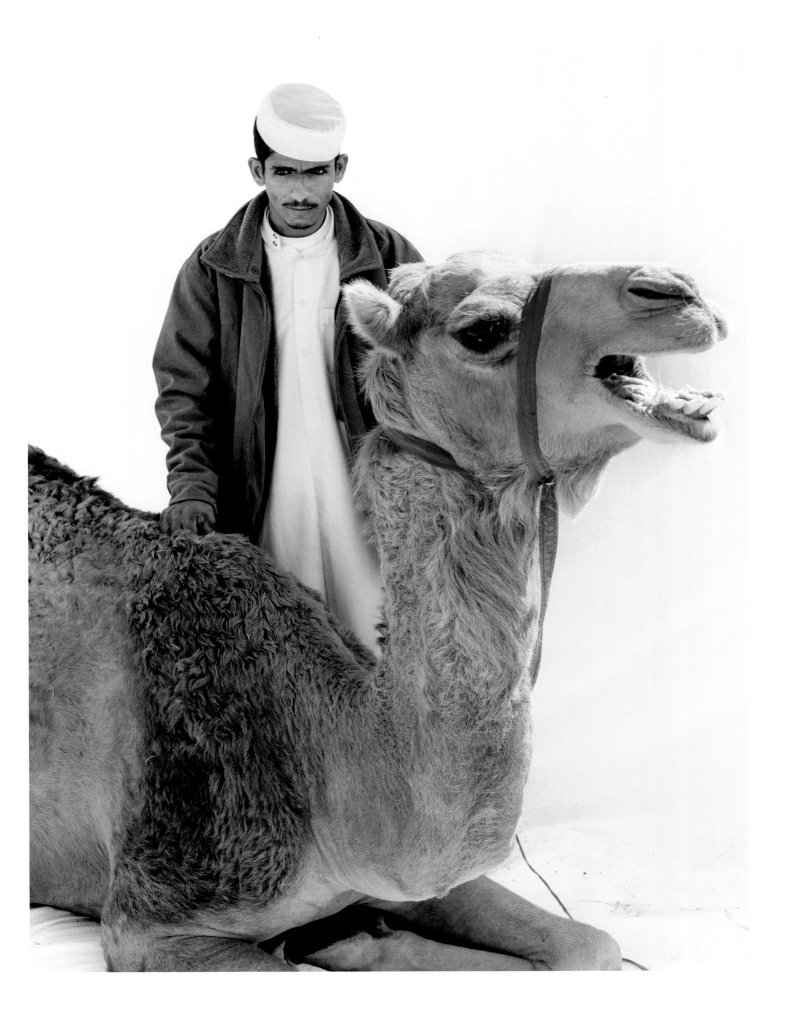

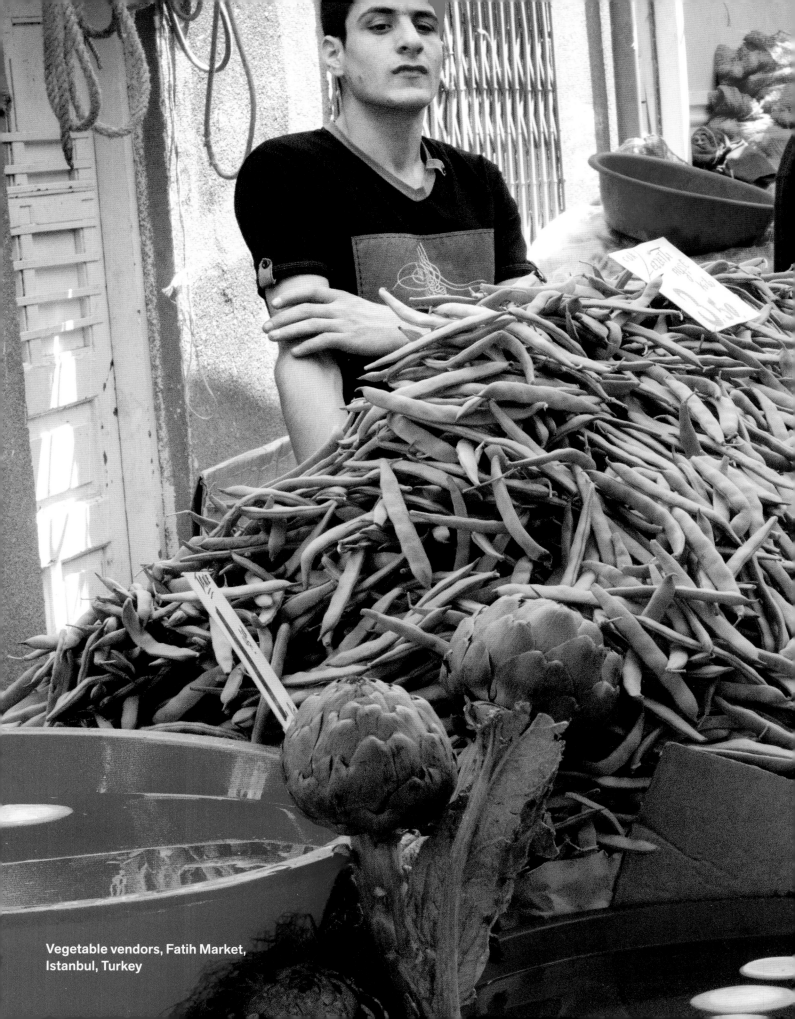

Vegetable vendors, Fatih Market,
Istanbul, Turkey

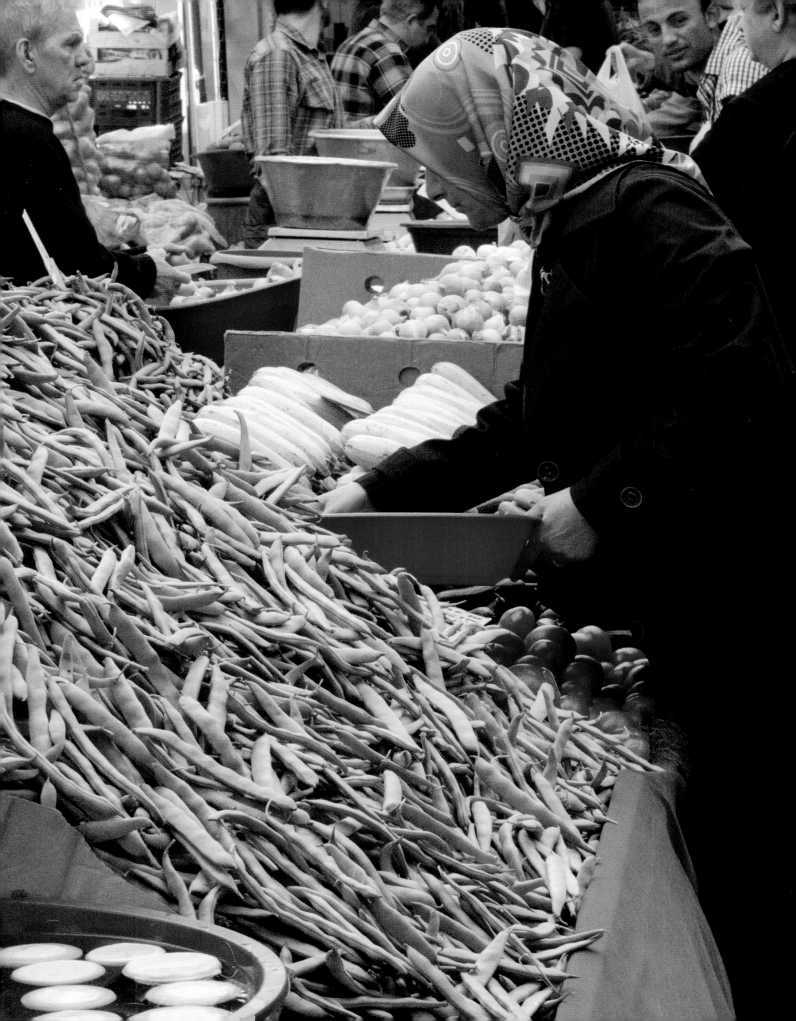

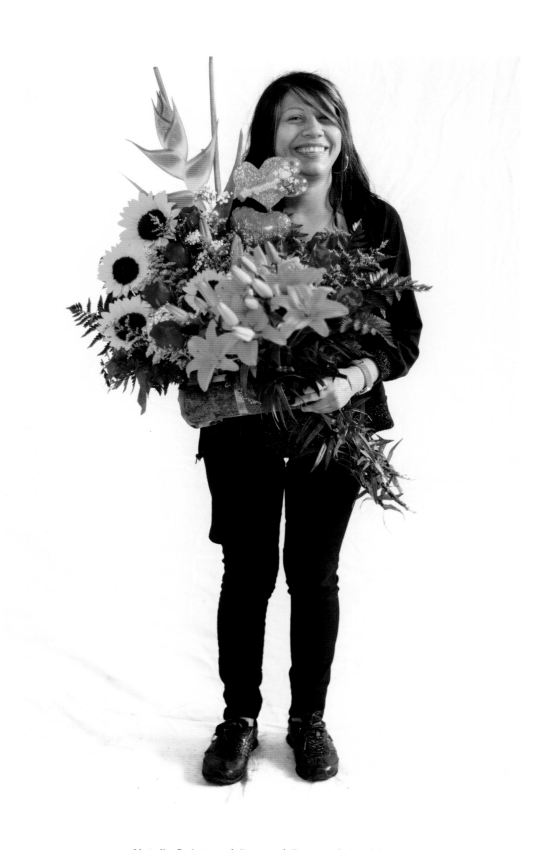

Natalia Quintana | flowers | Bogota, Colombia

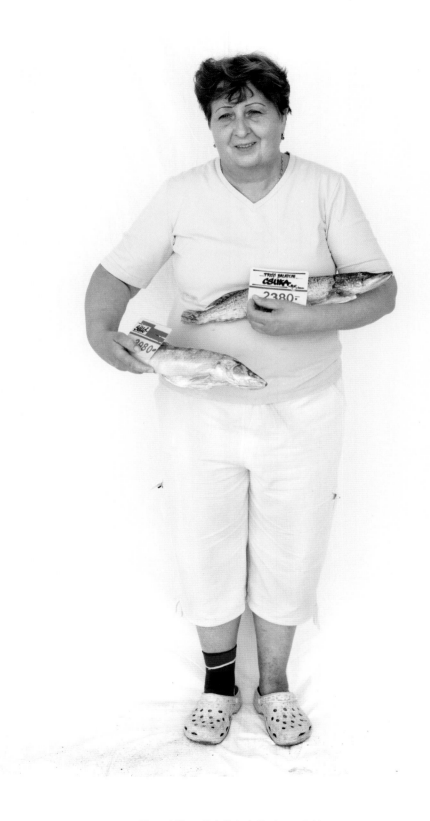

Hegyi Margit | fish | Budapest, Hungary

Dedic Suljo | squash, cabbage and garlic | Sarajevo (Otoka market). Bosnia-Herzegovina

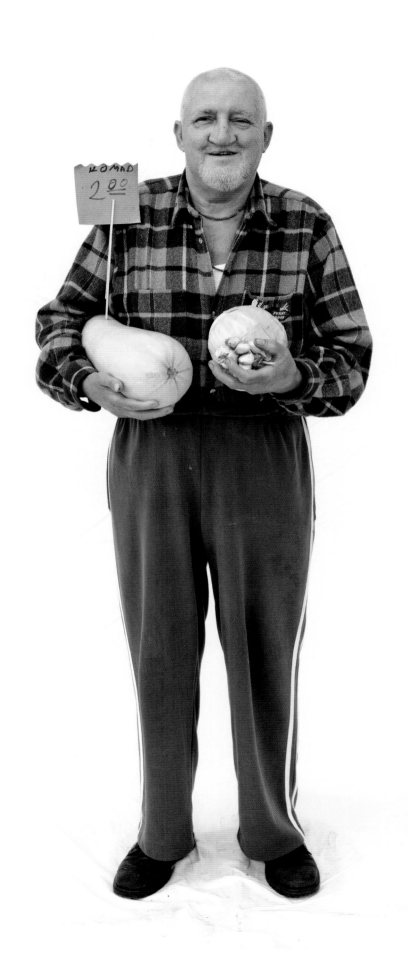

Mdeye Diop | lettuces | Dakar, Senegal

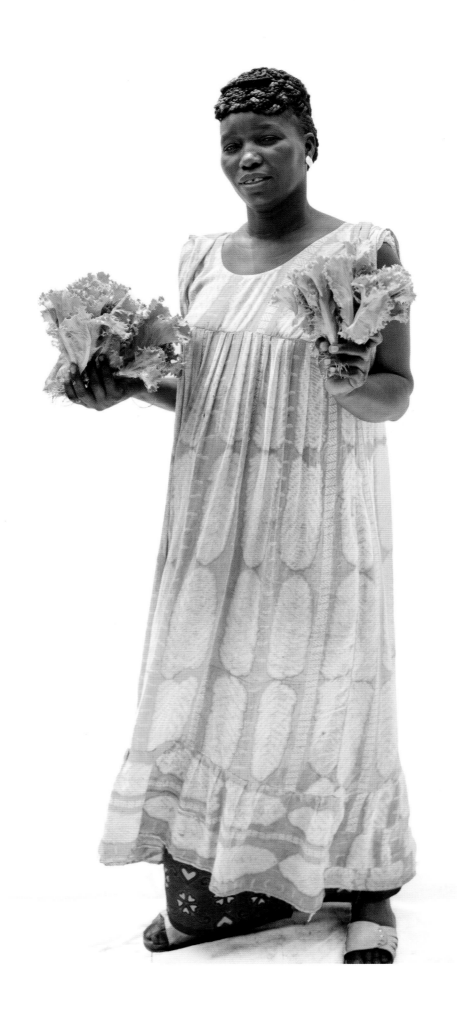

Maria Elmevivida Pastona and Jose Velano | market porters | Quito, Ecuador

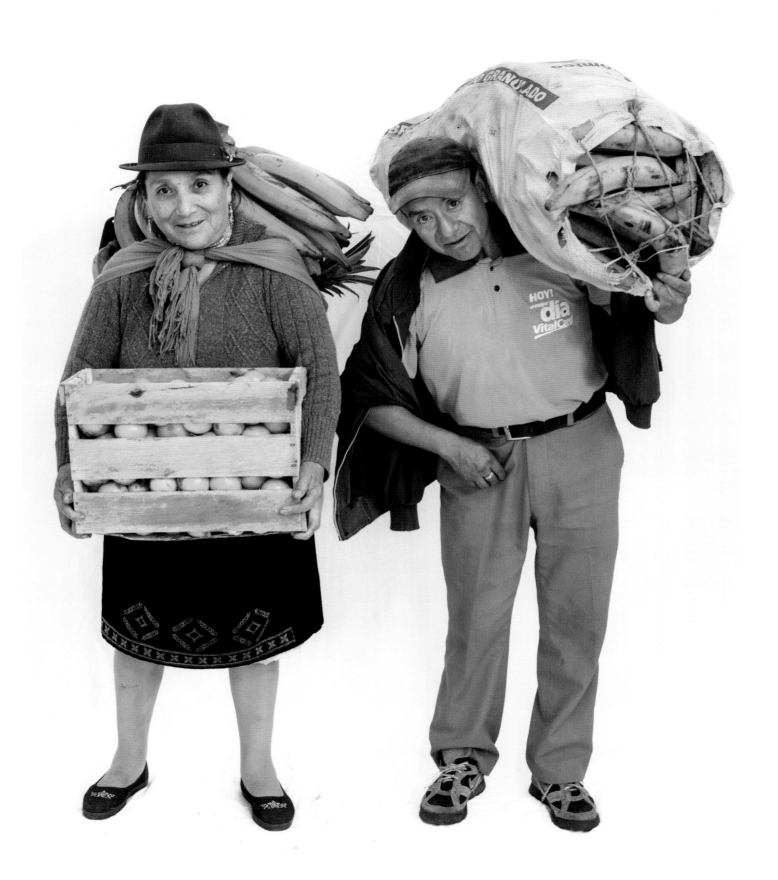

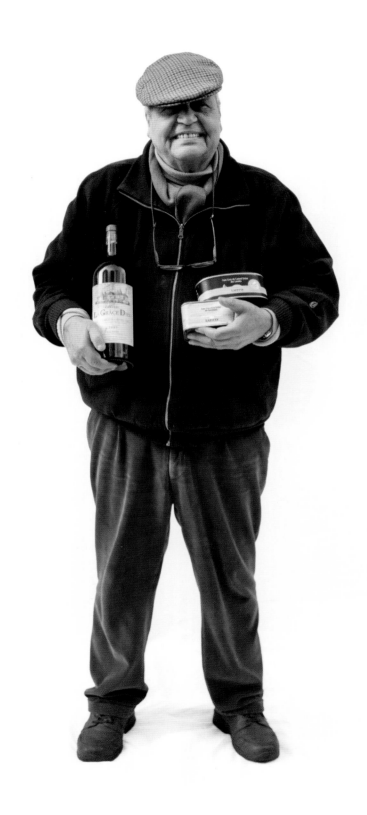

Jean Marie Gremillet | foie gras and wine | Paris (Raspail market), France

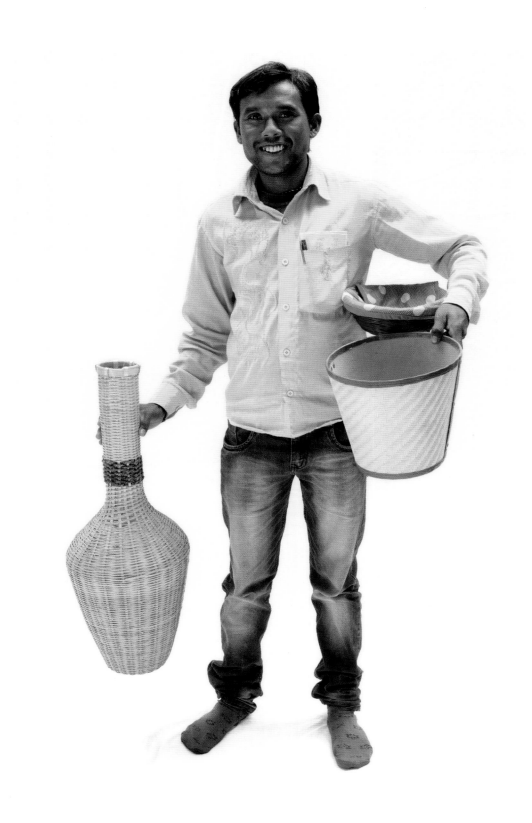

Suresh Hansda | bamboo baskets | New Delhi, India

Fishermen were selling seafood off the backs of their boats at
this market outside Vancouver. The vending process was a family
operation in each instance, with kids helping at all stages, and they
were doing a brisk business. We asked the parents to pose; however,
they said they were too busy. But they said the kids would do it.
Bingo! The kids enthusiastically left their vendor duties to pose
along with the products they were selling.

Huy Dinh | dungeness crabs | Steveston, British Columbia (Steveston Landing market), Canada

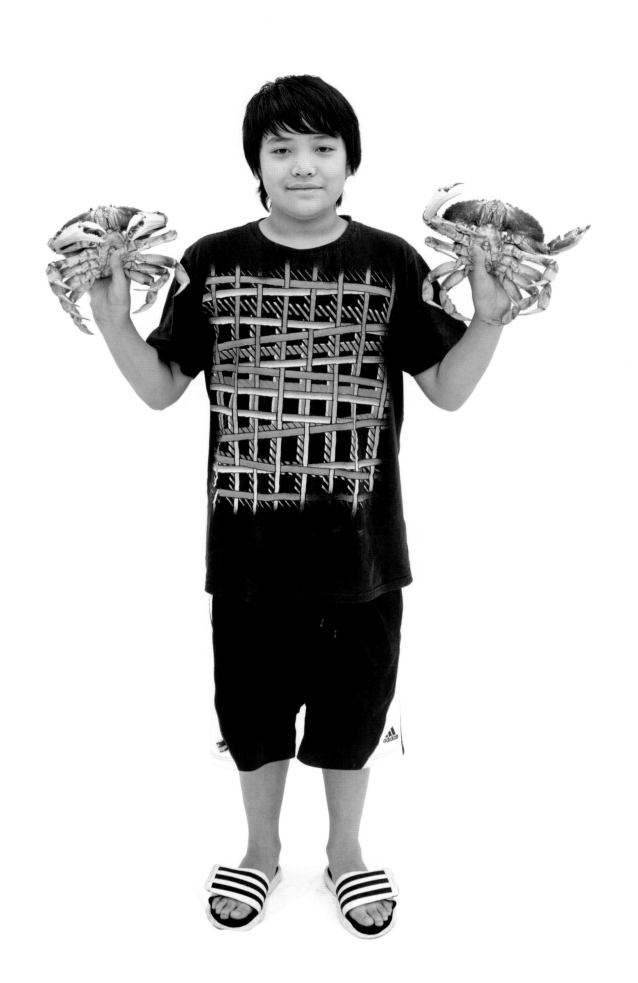

Edip Kahramen | watermelons | Istanbul (Fatih market), Turkey

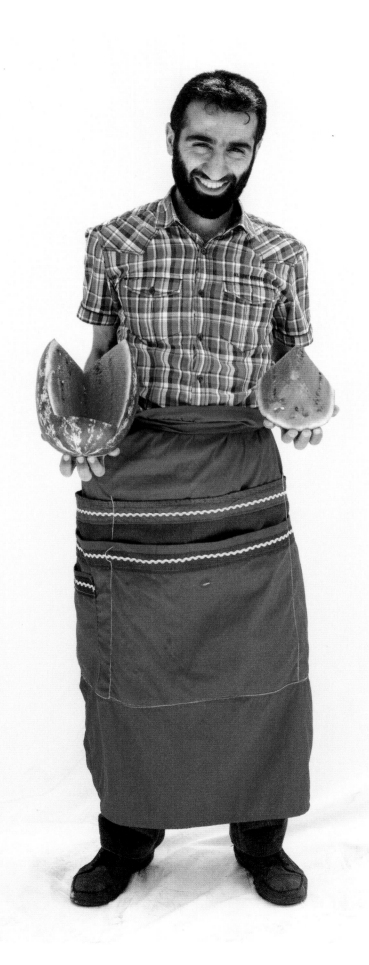

Naseran was selling dolls and other toys in the Sunday street market.
Our fixer asked her to pose, and after she secured her husband's permission,
she came to the backdrop. But before we could get the camera ready, she
flipped her scarf forward to cover her face. When the fixer asked her why,
she said she was Muslim and because of her religion's ban on idolatry did
not want an image of her face to be made. We felt this was a bit ironic, as the
principle item she was selling was dolls, but we complied with her wishes.

———————————

Naseran | dolls and other toys | Pataudi, (Nauhata Chowk market), India

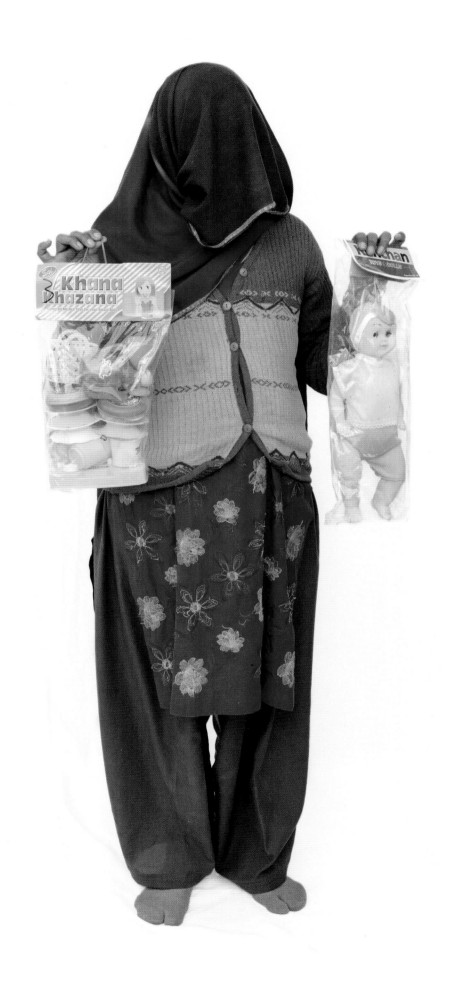

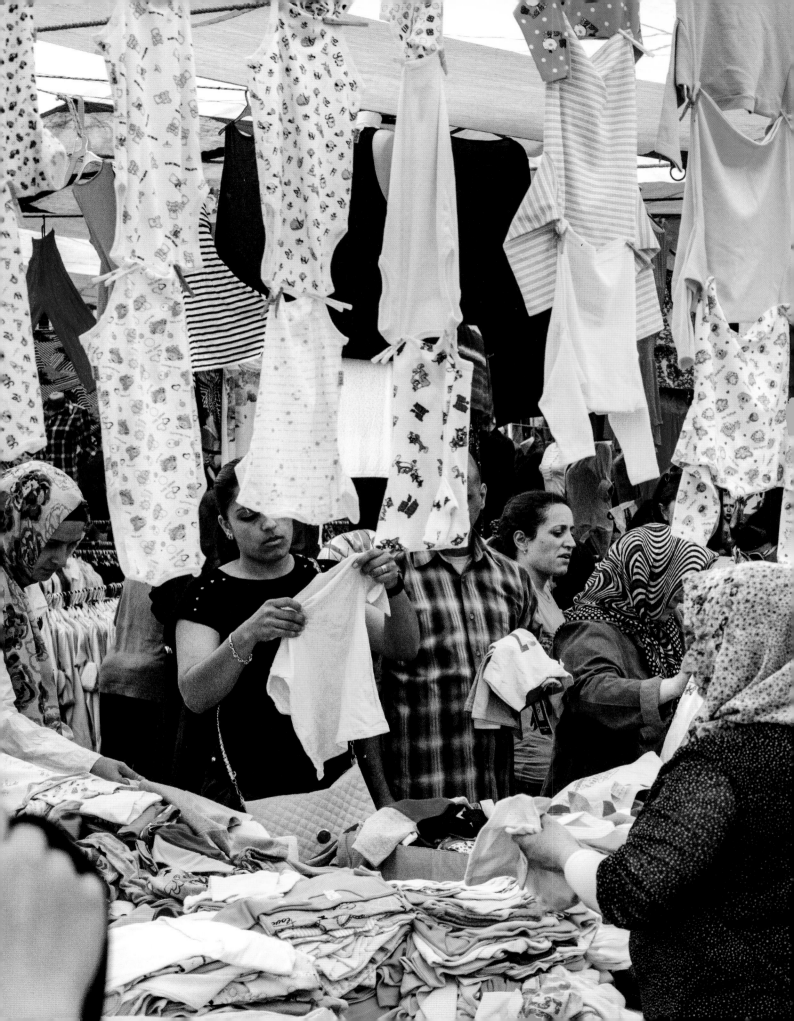

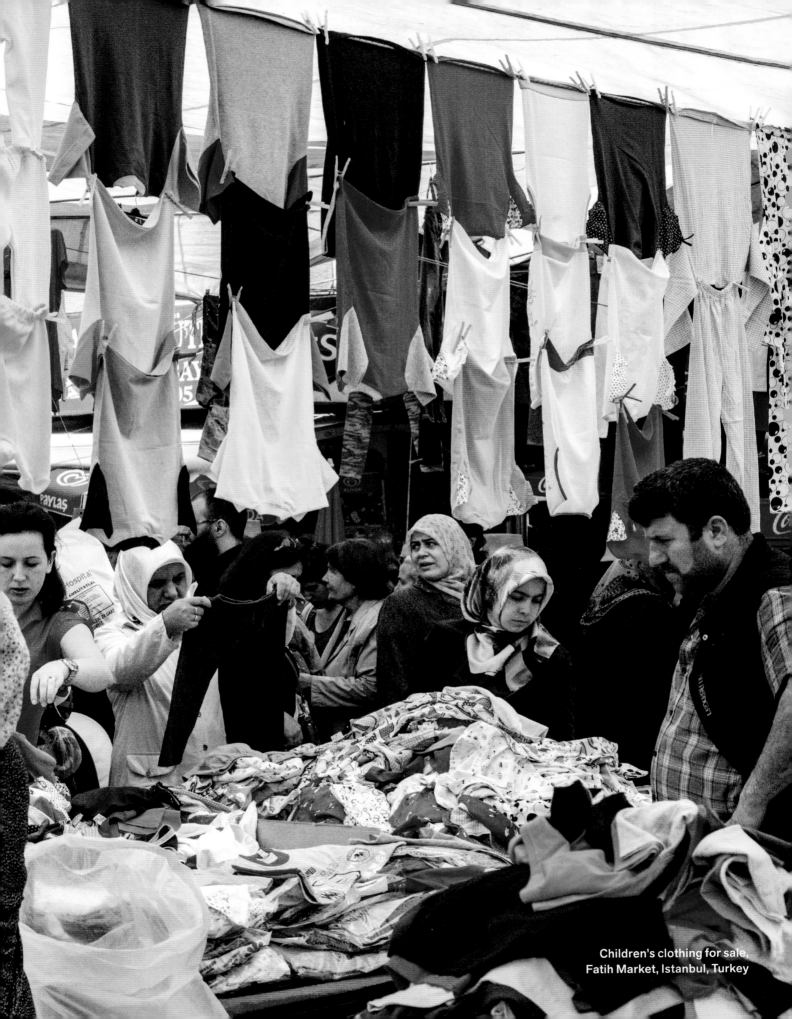

Children's clothing for sale,
Fatih Market, Istanbul, Turkey

Liliana Pina | coffee | Bogota (Central market), Colombia

We saw Stanislaw making the rounds in the market, doing a good business in yummy-looking breads and pastries. We asked him if he would pose, and he said he would when he got to the area where we were set up. He arrived, and we began taking images. Then his phone rang. He answered it and began what was a long and obviously very enjoyable conversation, never moving from the backdrop. So, we captured him talking, his goods, and the delight of his call. Life goes on…

—————————

Stanislaw Rol | bread and pastries | Warsaw, Poland

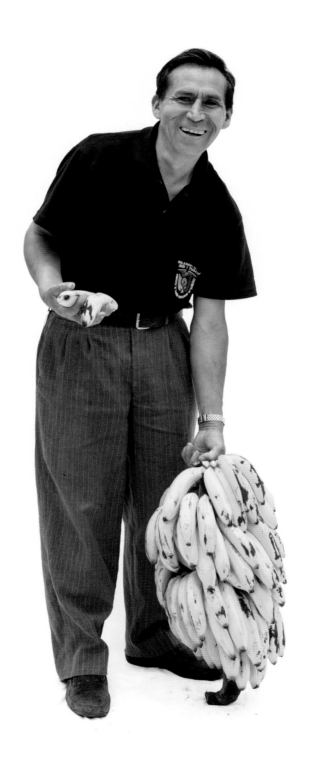

Jorgo Vilcaguano | bananas | Saquisili, Ecuador

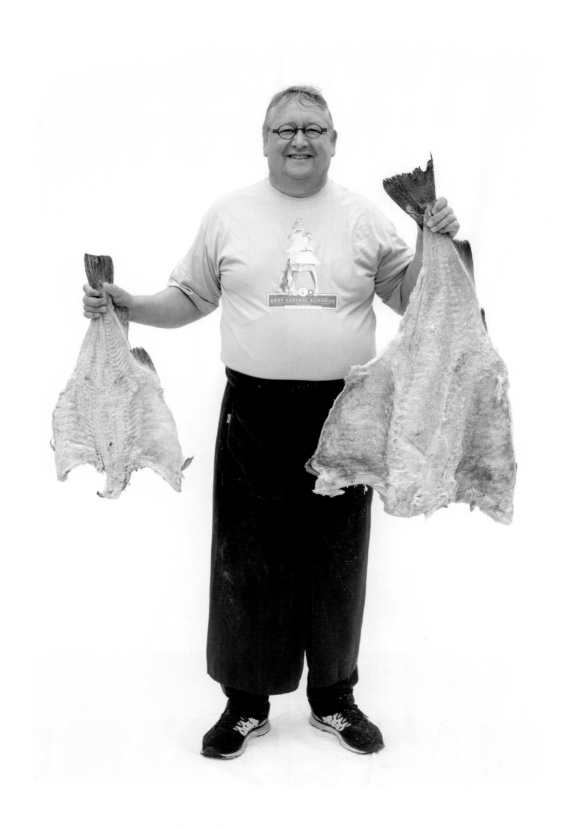

Knut Garshol | Salted and dried cod fish | Oslo, Norway

Volenszki Peterne | fruit | Budapest, Hungary

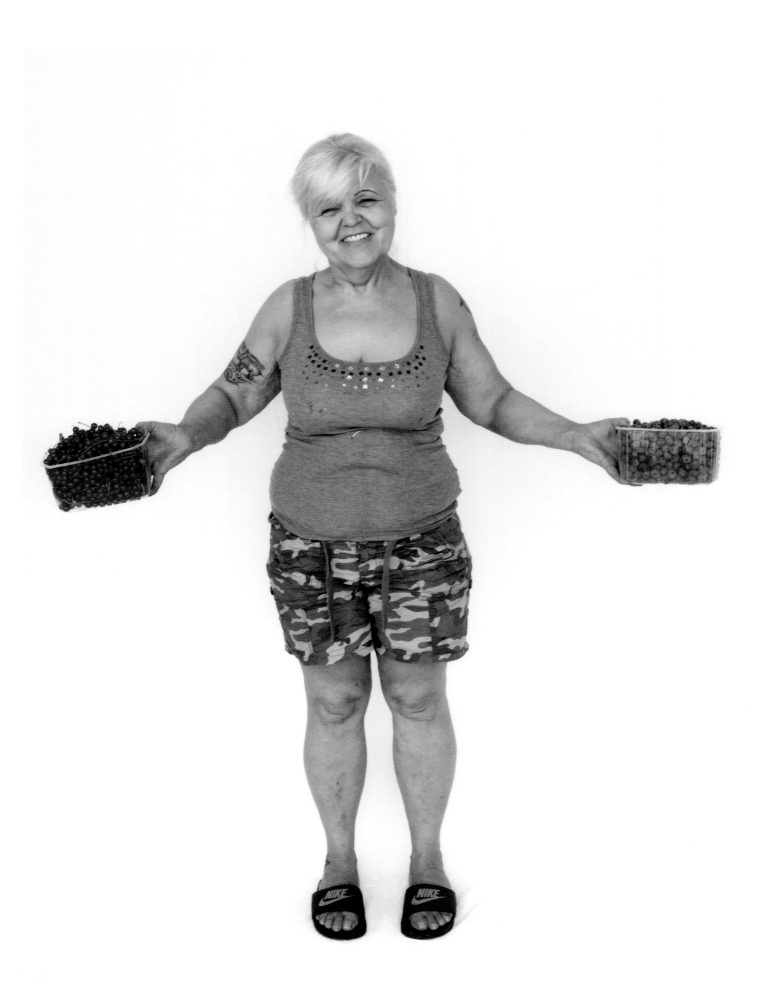

The creativity of market vendors to meet the needs of their customers seemed boundless. Mukash had a niche business selling items associated with weddings. The most unusual items were made from currency, rupee notes folded into shapes and designs and then fashioned into decorative hangings. It was a clever way for a wedding guest or relative to make a gift to the bride and groom that is both attractive and, in effect, a savings account.

Mukesh Kumar | Wedding accessories (garland of folded rupees and slippers) | Pataudi (Bada Bazaar), India

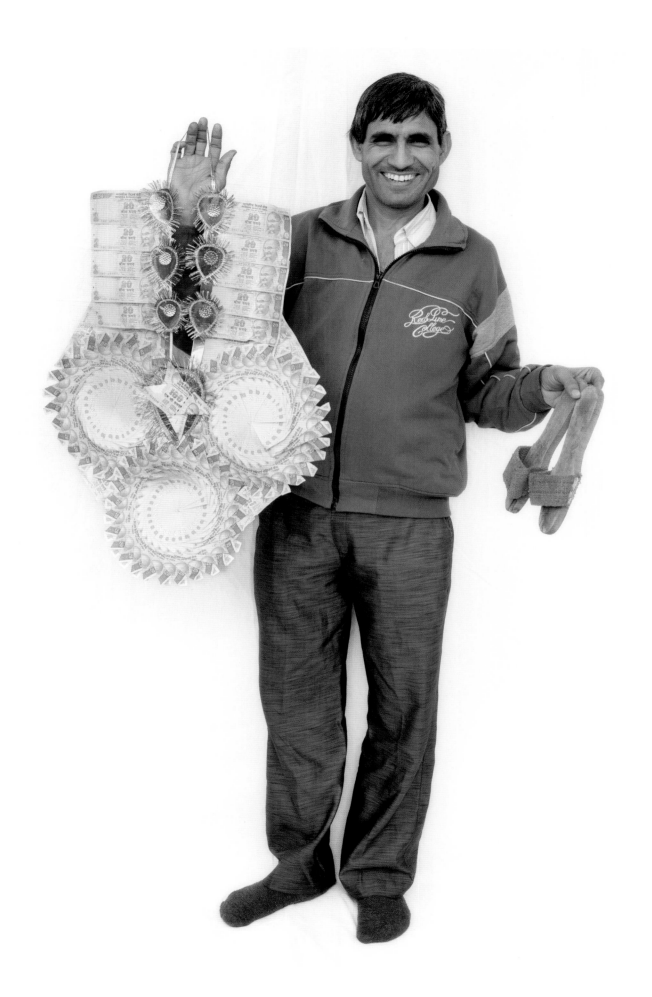

Ayse Yayman | wigs | Istanbul (Fatih market), Turkey

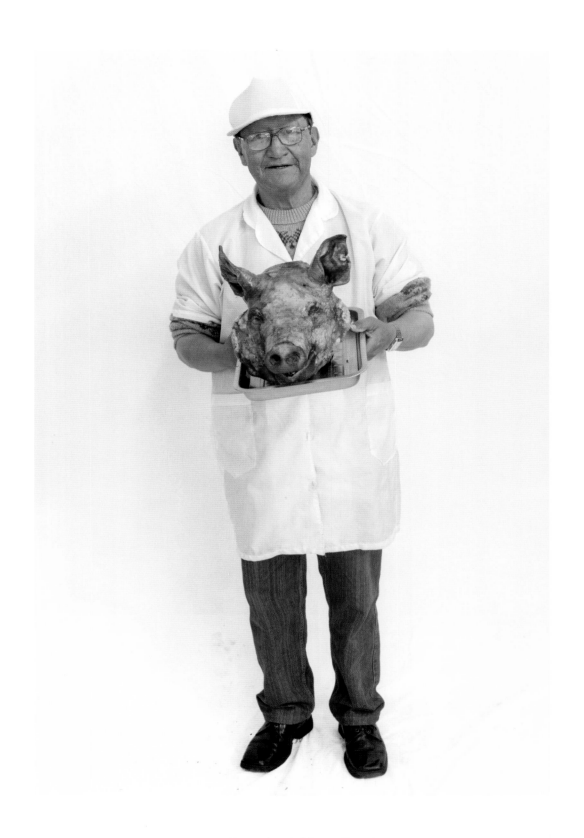

Angel Leon | pork | Quito, Ecuador

Luis Carerra | shoe repair materials | Saquisili, Ecuador

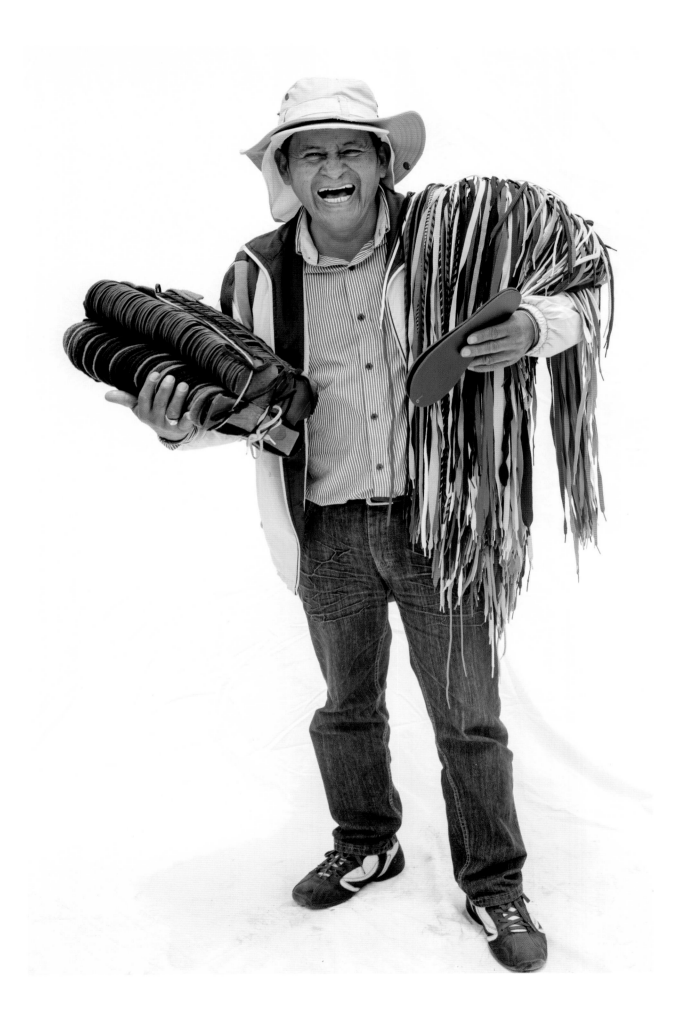

Miriam van Beek | leather and fur clothing | Warsaw, Poland

Sometimes we played an inadvertent marketplace role. As soon as Maria arrived at the market, she agreed to be photographed with her sheep. As she walked toward us, however, another woman ran over to her, offering to buy the sheep. Maria played it cool, continuing to the backdrop. In pursuit, the confused buyer pulled out more money, waving it at Maria, who still ignored her. In a final effort, the buyer added yet more money to the wad she was waving. By then we had finished the portrait. Maria took the money and gave the leash to the buyer. As Maria left, she gave us a sly smile.

Maria Ernestina Merchan Rojas | sheep | Mongui, Colombia

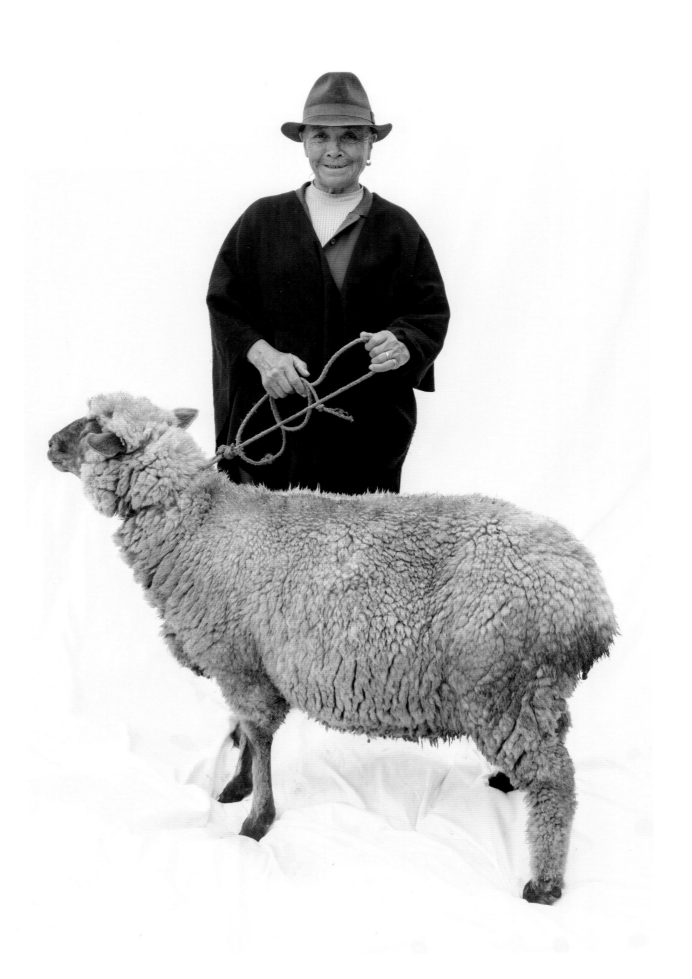

A sizeable number of vendors in these markets were immigrants to the country. The offerings in the markets by recent immigrants often were more meager than better-established vendors. What they may have lacked in offerings they often made up in social skills. This vendor of vegetables, who was from Iran, had an out-sized personality that was the key to his success.

Mirza TajAlrahman | vegetables | Doha, Qatar

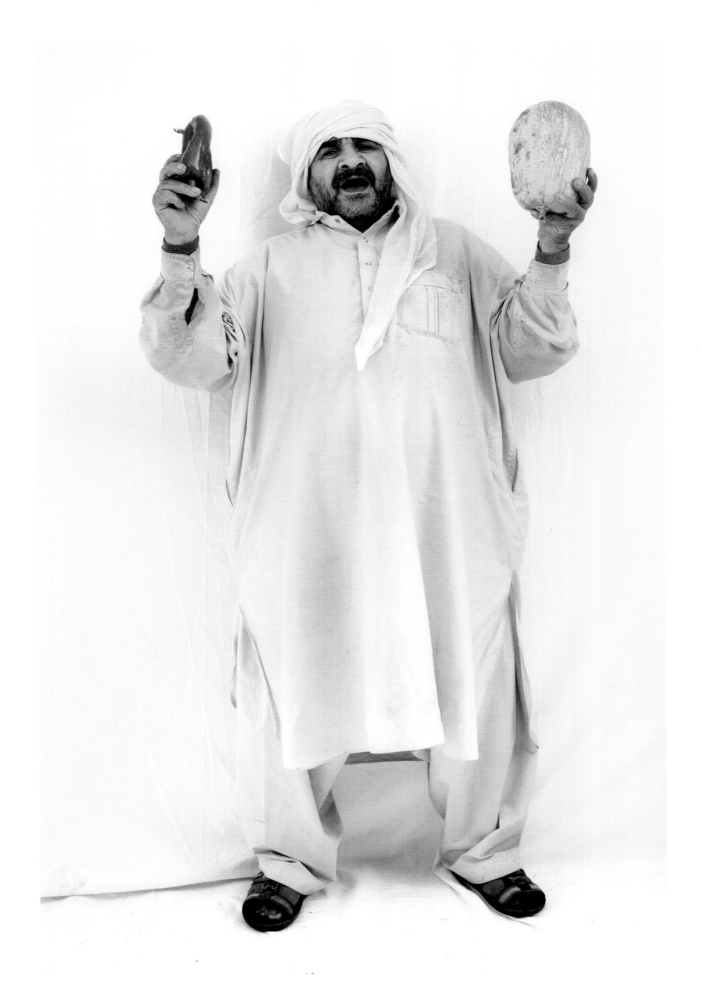

Rony Rolando Tagual Socop | cucumbers | Chimaltenango, Guatemala

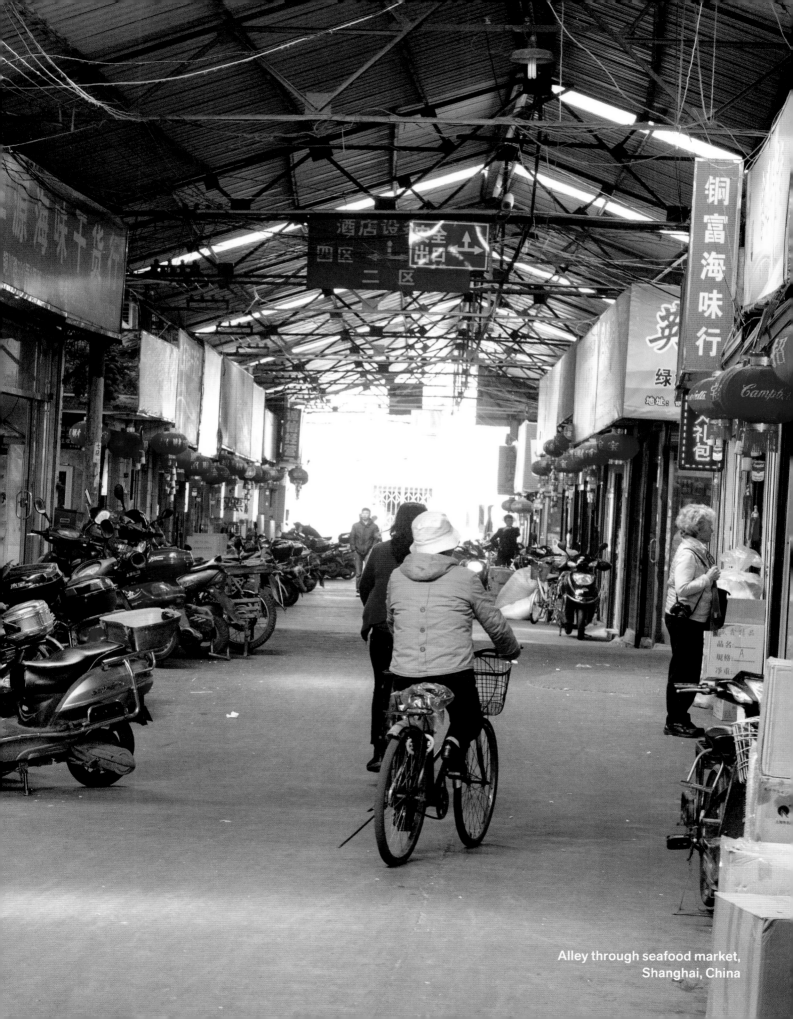

Alley through seafood market,
Shanghai, China

Ali Ersari | simit breads | Istanbul (Fatih market), Turkey

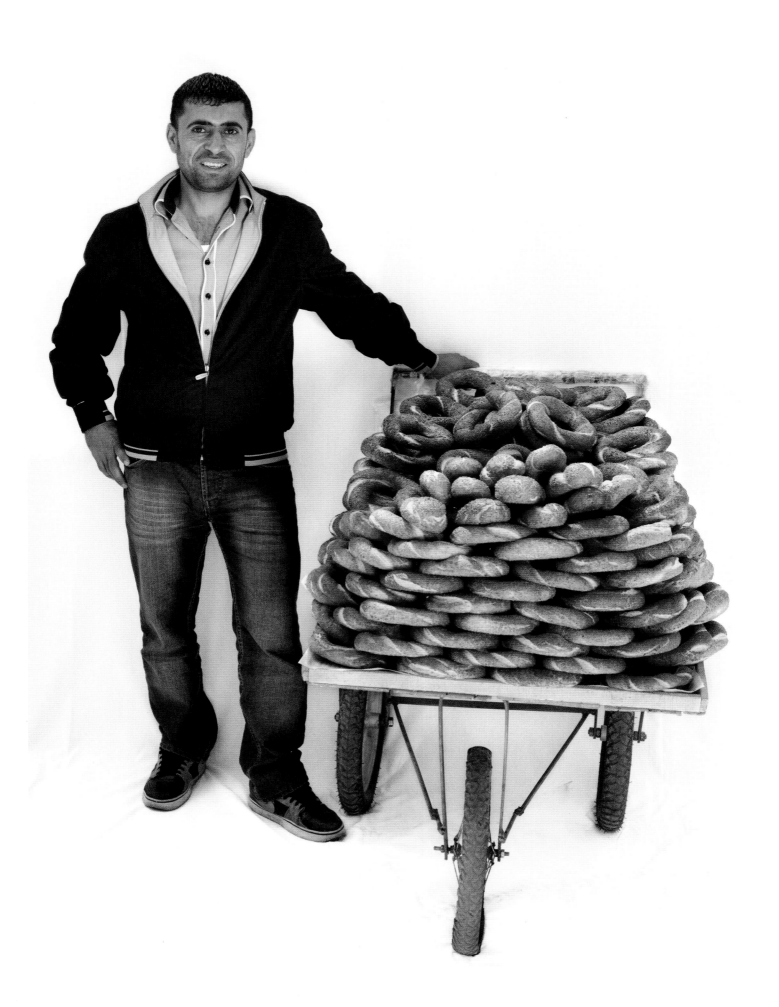

Chen Ti Qiang | sausages | Beijing (Shu Men Market), China

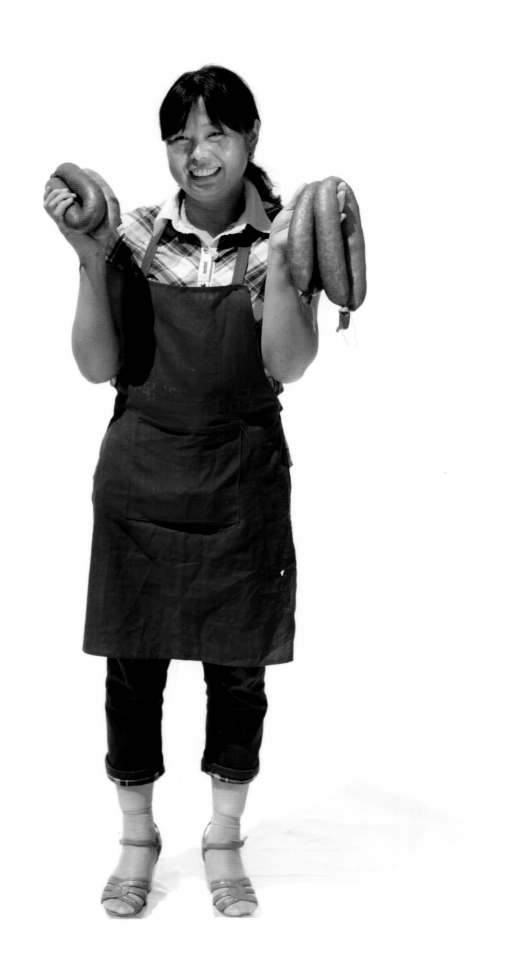

M. Esperanca | cheese | Paris (Raspail market), France

Elmer Sicay | spices | Chimaltenango, Guatemala

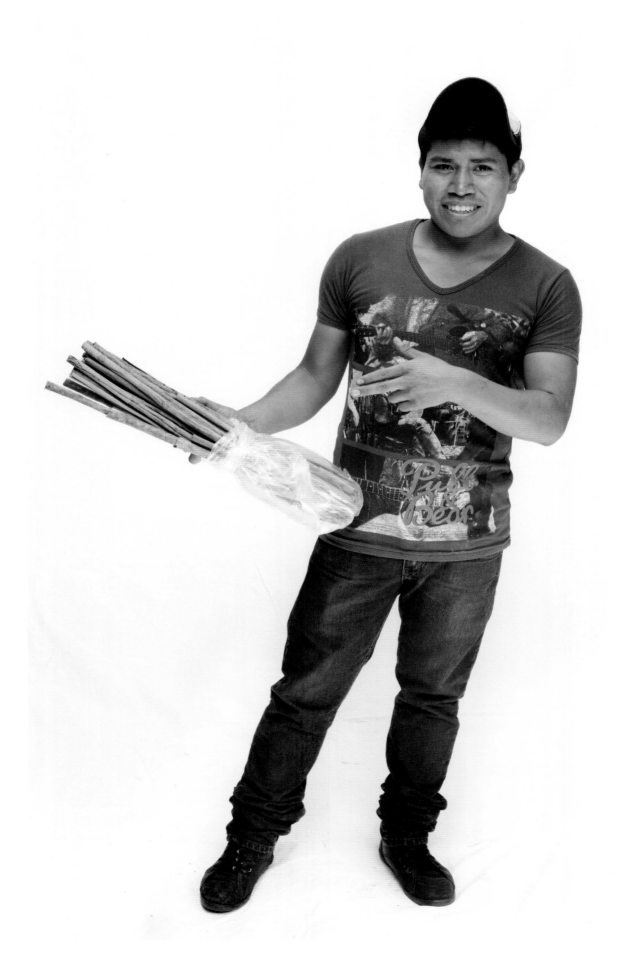

The public markets we saw showed frequent gender-leveling opportunities. Women often took charge of sales and managed them in all respects. They sold to men and women and were as assertive with the men as with the women. And they did not always turn to men when there was heavy labor to be done. Here Senora Balseca hardly shows any strain while carrying this sizeable chunk of beef.

Delia Balseca | meat | Quito, Ecuador

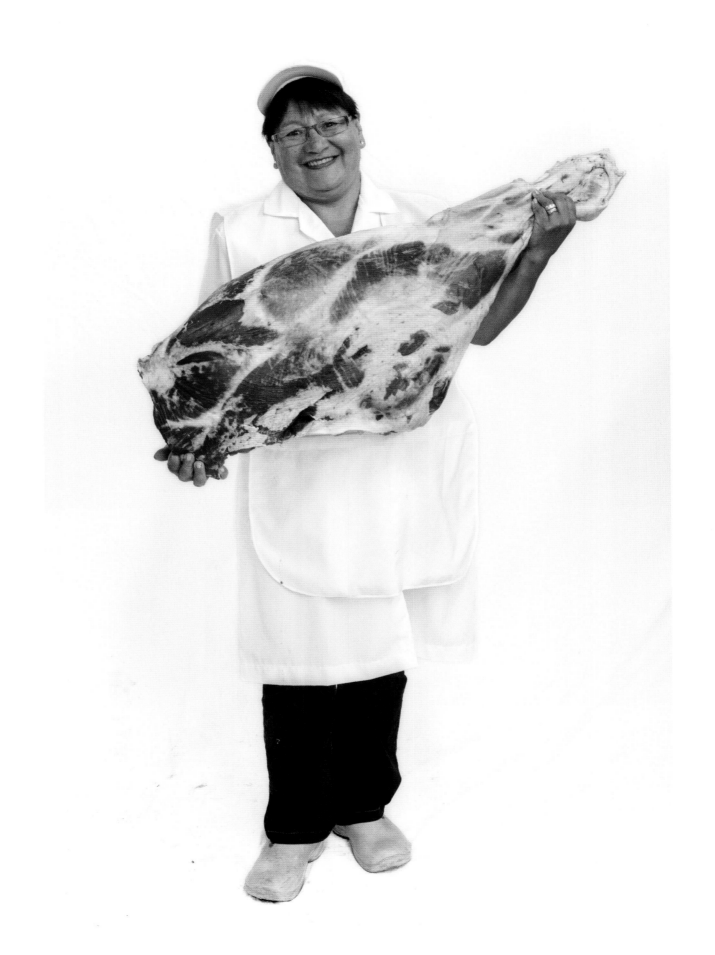

Duan Ma | meat | Longh Tanh, Vietnam

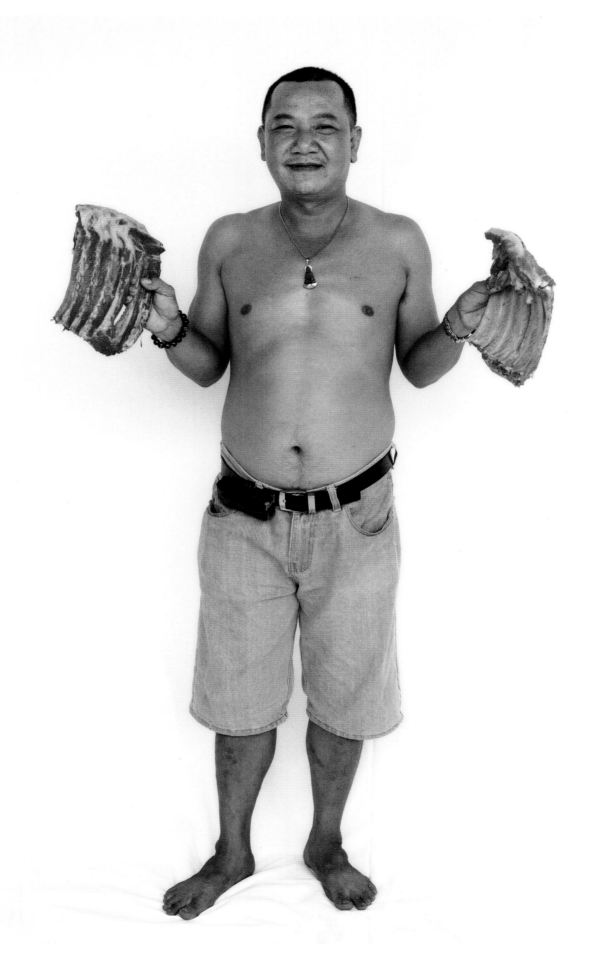

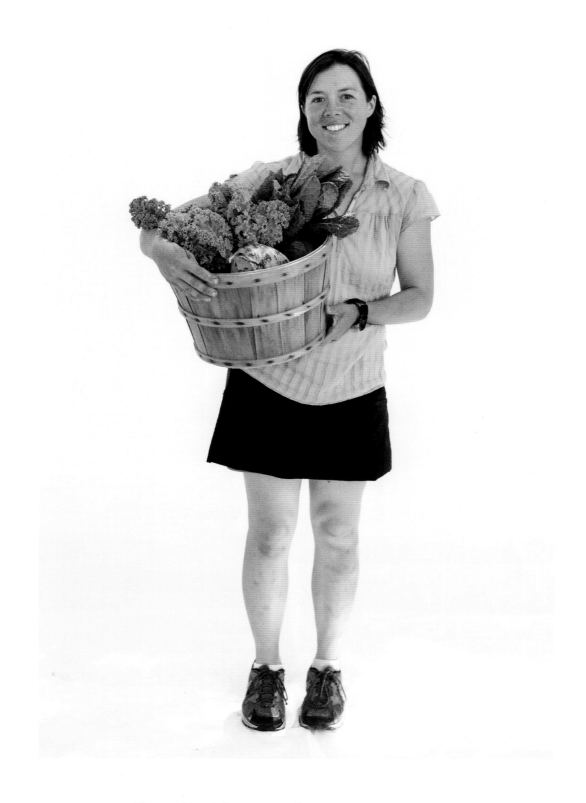

Theresa Mycek | vegetables | Chestertown, Maryland, USA

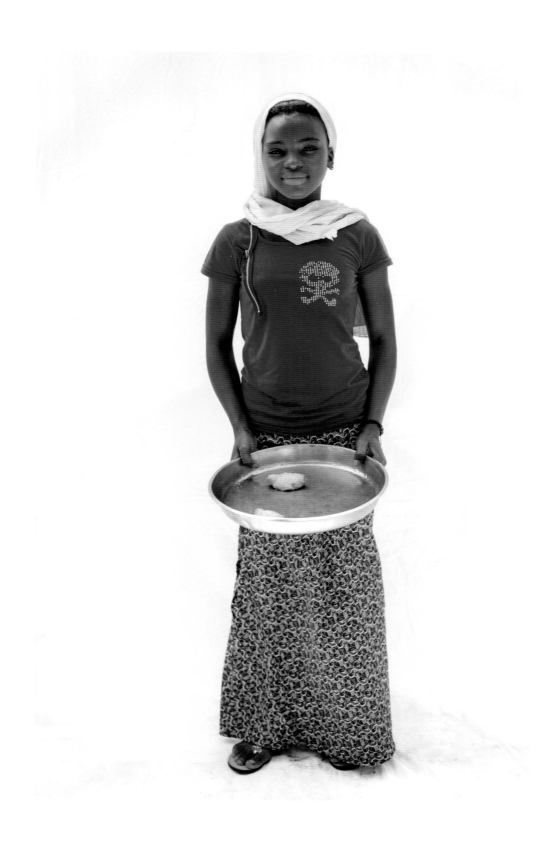

Daba Sall | biscuits | Dakar, Senegal

Sunchai Saetung | fish | Chiang Mai (Avitha market), Thailand

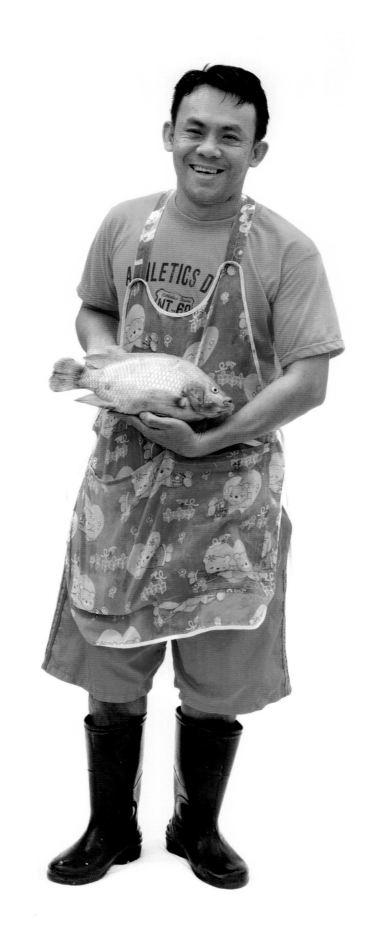

Sidhik Sidhikmanzil | fish | Doha, Qatar

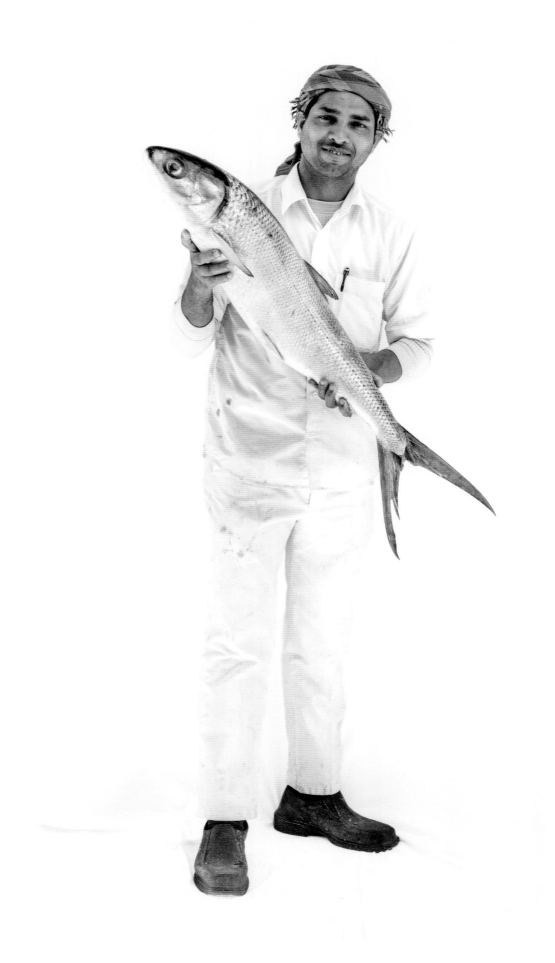

Because public markets in urban areas offer better economic
opportunities, vendors frequently come long distances to sell their
wares. Even when the goods were perishable, they would be brought
on buses, motorbikes, or in trucks that were passing through. Here
the vendor selling his metalwork in Delhi hails from Rajasthan,
which is 5-8 hours away over the roads.

Ramdev | handmade metal objects | New Delhi, India

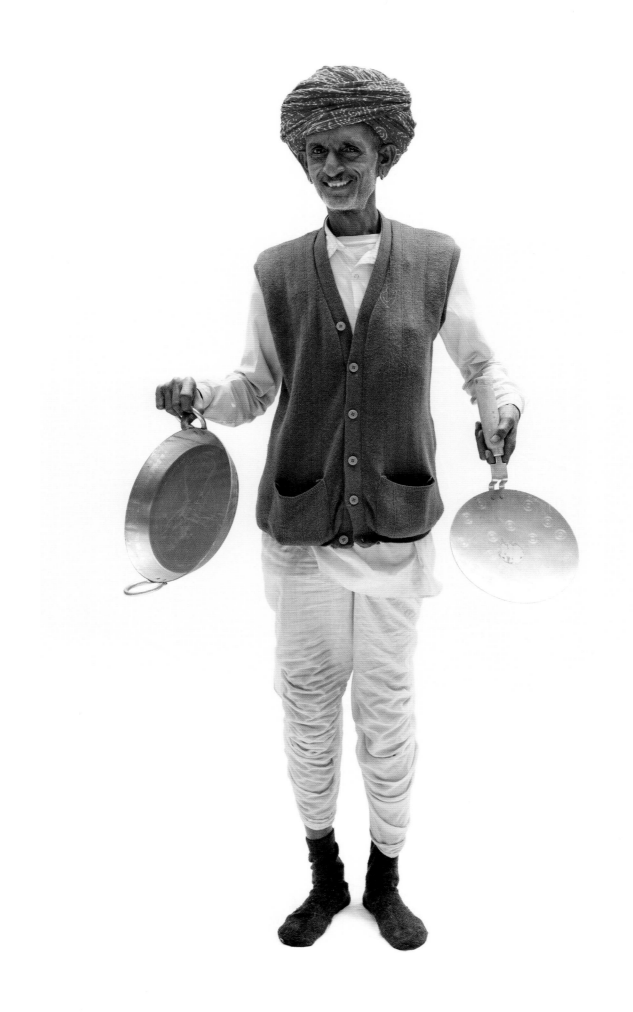

Mucahid Turak | jeans | Istanbul (Fatih market), Turkey

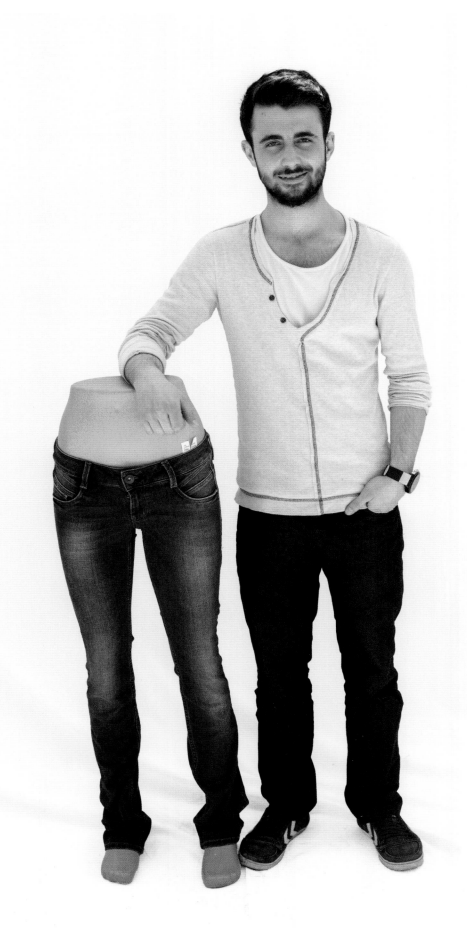

The used clothing market in Shanghai is a fashionista's dream. Used knock-offs of European designs are available at excellent prices. Different vendors specialize in shoes, formalwear, outerwear, dresses of different styles, leather goods and much more. Every imaginable denim item is there…somewhere. "Street" stylists can find elements to make them unique. Or, if you are just looking for a good pair of boots, they will be there too; if you can find your size. It caters to those who seek an establishment look, as well as those who wish to appear anti-establishment.

———————

Gi Xifang | handbags and boots | Shanghai (Used clothing market), China

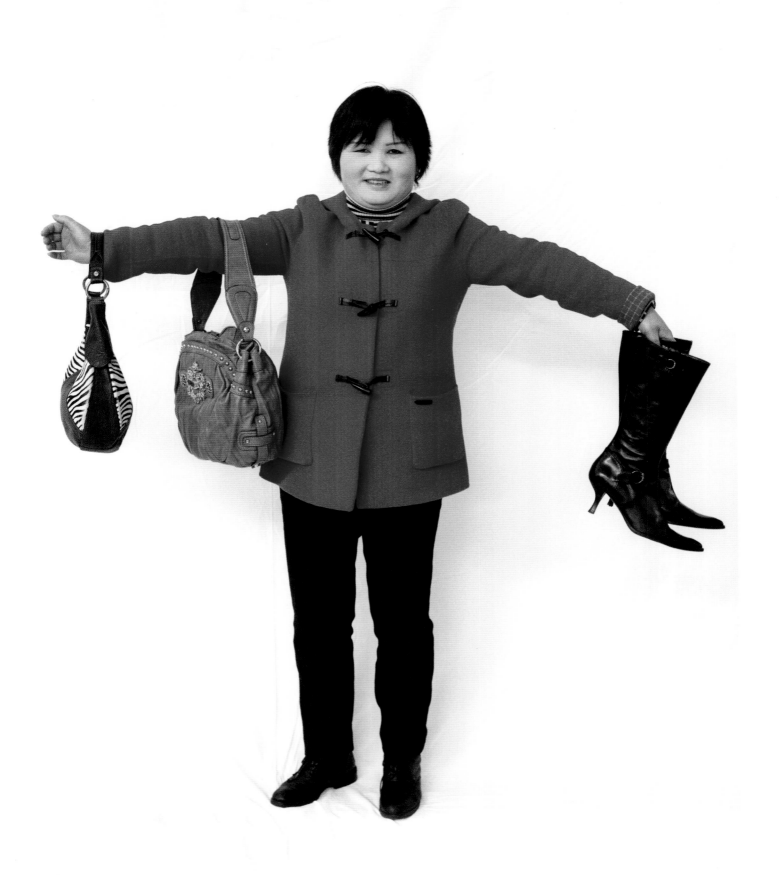

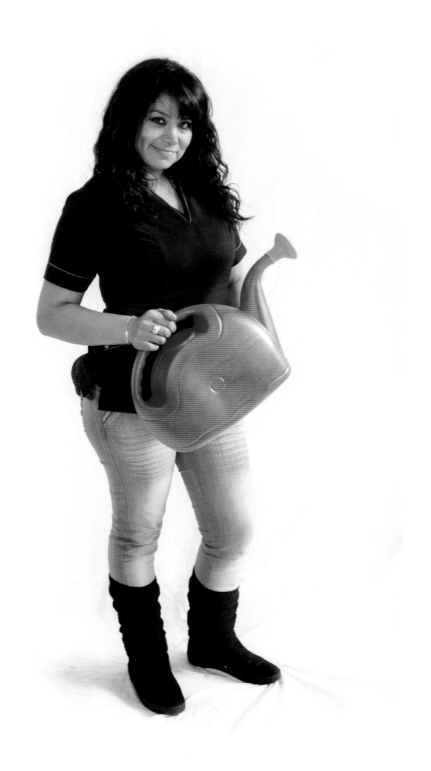

Talian Para | watering can | Bogota (Central market), Colombia

Ismail Deli | women's underwear | Istanbul (Fatih market), Turkey

This vendor in a pop-up market in a South African township is an economic refugee from Zimbabwe. Knowing the building trades, he said he decided to start a little business selling the plumbing needed to install flush toilets. They are highly valued (one party in a recent election used the slogan "Flush Toilets for Everyone" as a major political message). He said that business was a bit slow, but that he was confident that he would succeed.

Constantine Rocha | plumbing supplies | Cape Town, South Africa

Given the social function of markets around the world, within them there always was a demand for refreshments—whether tea, water, biscuits or other snacks. Here, we spied a couple of teenagers moving within the livestock market offering beer, with a young relative of one of them wielding an opener. They were just getting started when we photographed them, but later we saw that their business was doing vey well, with knots of (mostly) men sitting around quenching their thirst with beer.

Abel Guaque (L) and William Hurtado (R) | beer | Mongui, Colombia

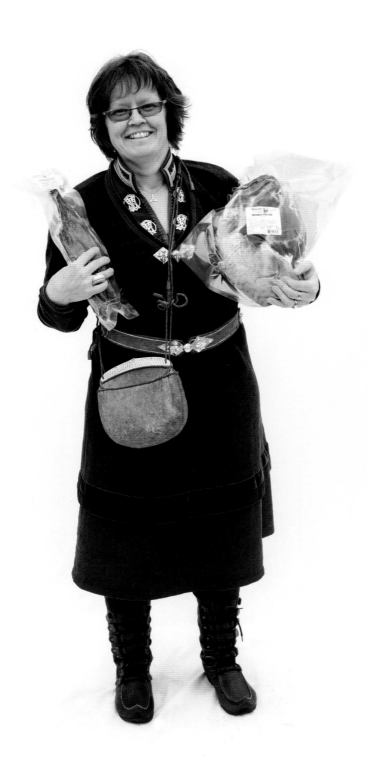

Unni M. Fjellheim | reindeer meat | Oslo, Norway

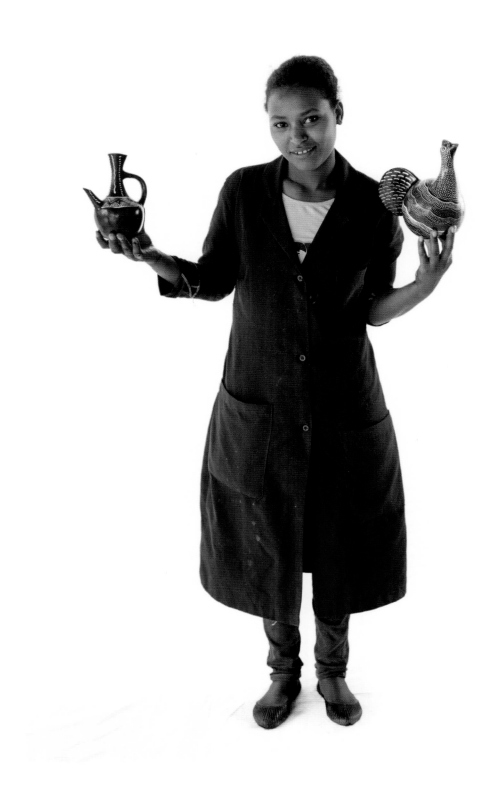

Marya Wale | pottery | Addis Ababa, Ethiopia

Nhien Pham | clothes | Long Thanh, Vietnam

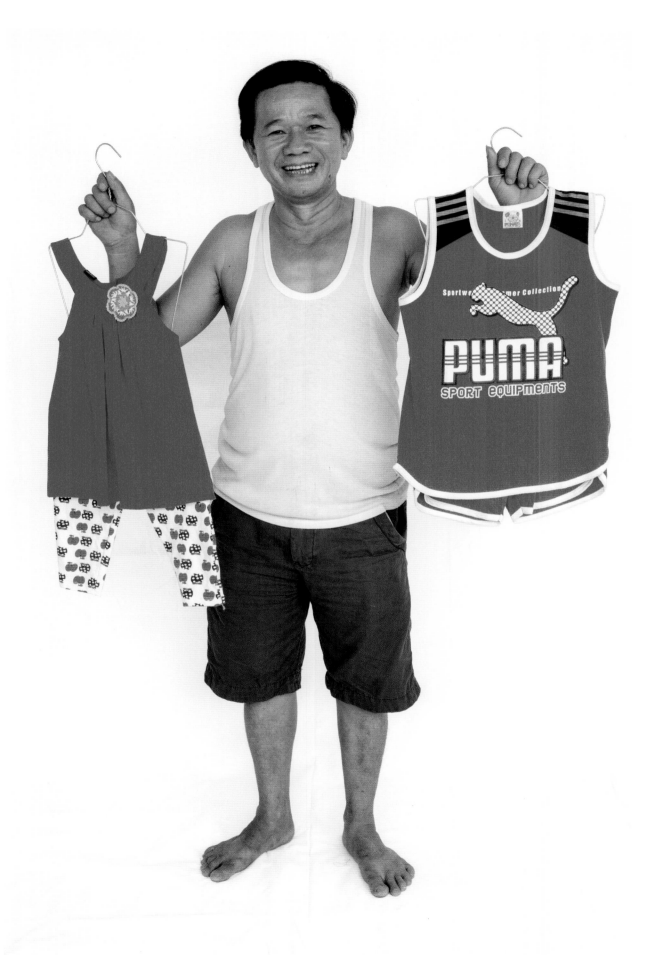

Nancy McTear | purses and vests | Chestertown, Maryland, USA

Wally Parks | beets | Charlottesville, Virginia, USA

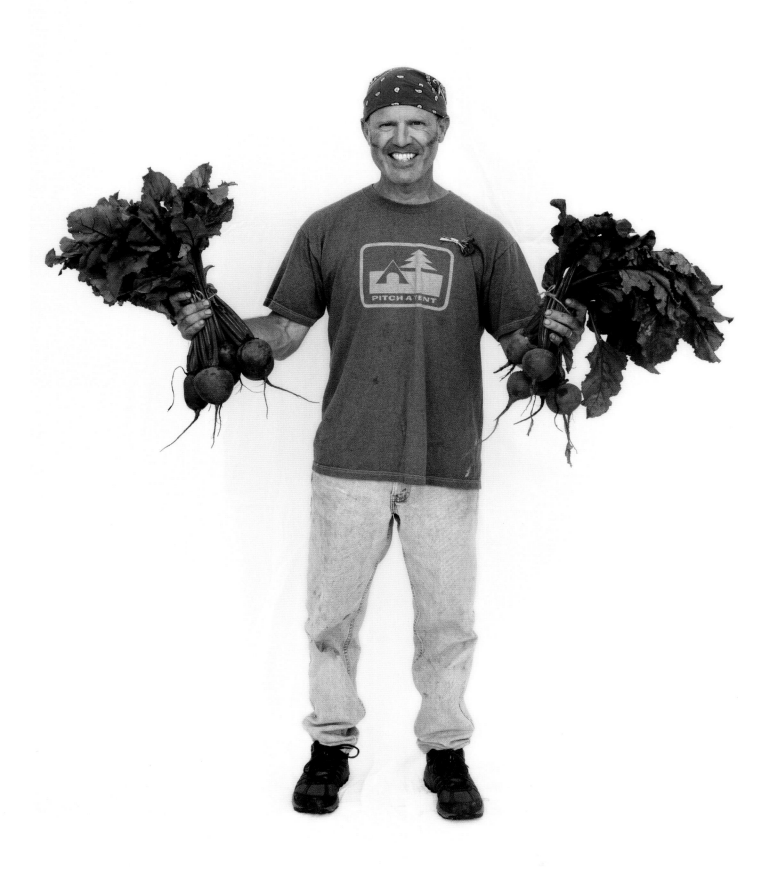

Although the Shanghai used clothing market mostly focused on wearables, the people who came there seemed also to focus on other off-the-wall and unique items. This vendor, himself a bit of a caricature of a 20th century hipster, apparently realized that, and had a small shop that was filled with quirky and unusual merchandise…well beyond the run-of-the-mill flea market items. He was proud of the stuff he had and quick to cooperate with us despite a steady flow of customers.

He Weimin | used interior decorations | Shanghai (Used clothing market), China

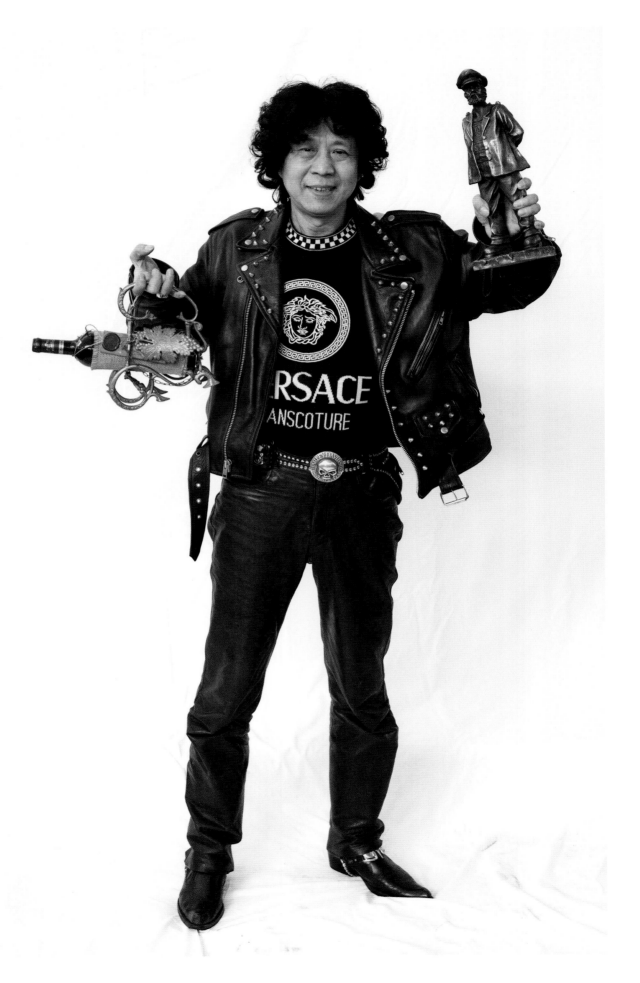

This woman, we were told, was the president of the vendors'
association in this market. It was easy to see how she could be
popular with her colleagues, as she was gracious and warm with us,
and a bit impish and dramatic as well. In the ebb and flow of the
market she moved around to make sure all was going well, all
the while selling her own produce. Her theatrical moves, as here,
only made her more charming.

Piedad Mullo | corn | Quito, Ecuador

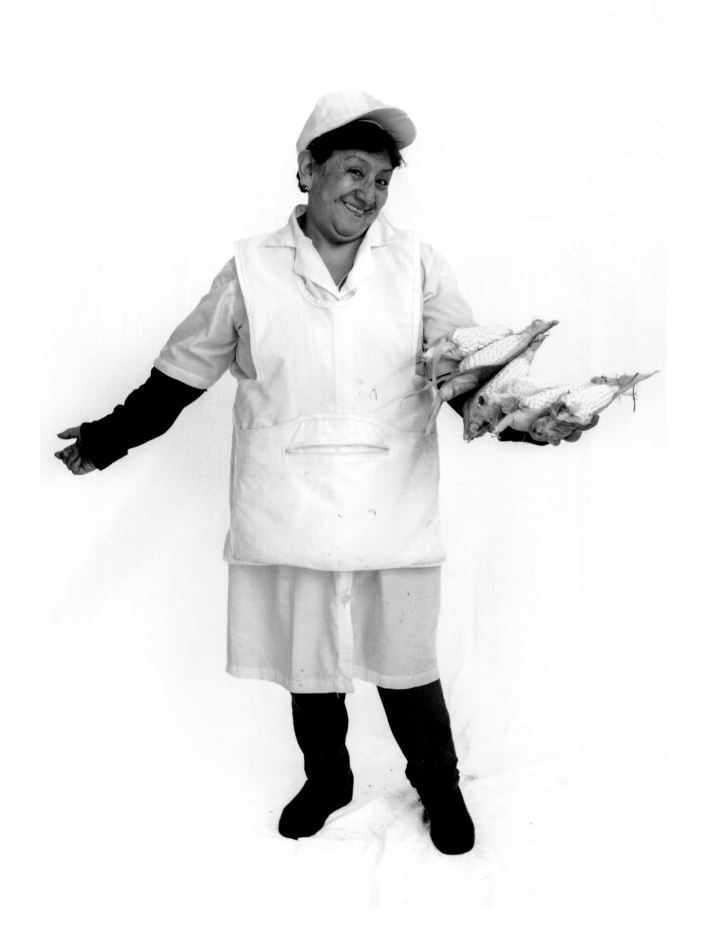

Fixers

This project would never have been possible without the work of many local people, known as 'fixers," whom we engaged to facilitate my interaction with market personnel.

Fixers are a major part of international journalism generally, especially in photojournalism and documentary photography. They provide a wide range of services, which can include researching the subject of the reportage, translating oral and written communications, getting necessary permissions, dealing with subjects (in our case the vendors), explaining cultural nuances and resolving cultural conflicts, securing drivers or vehicles or sometimes driving themselves, and helping with the technical aspects of the journalism, especially the photographic process. For us they often were the icebreakers, explaining the project to the vendors, including why we could not pay them for their photos (surprisingly only a handful of vendors across the world declined to be photographed because of lack of compensation), and getting their buy-in. They also dealt with market management and any security personnel.

Finding fixers was an interesting process. In all instances it was through a network of photojournalists and local friends around the world. Some fixers were themselves well-trained journalists who delighted in working on the project as an assistant. A very few were professional fixers, but mostly our fixers were doing this as a "side-hustle." Their principal occupations ranged from IT professional, to student, to print journalist, to clergyman, to legislative assistant, and to smart people who were simply between jobs, to name a few. I am still in touch with many fixers on this project, and a few have become very good long-distance friends.

There are enough memorable vignettes involving the fixers to write at least a chapter. I still have visions of one very savvy young woman (a university student in journalism) in the very male-oriented country of Qatar, who persuaded the uniformed policeman in the main market that we did not present a threat to anyone. I also recall a fixer in India who successfully helped manage of crowd of about 100 curious local people so they did not get in the way of the photography (the secret – he appointed a guy who was standing around to be our representatives to the other local people – suddenly the guy had status and authority and became an excellent crowd-control specialist).

But almost without exception, we had good relations with everybody in every market in which we worked. In markets where we were able to stay for a few hours, we often became a temporary part of the social structure of the market. For example, in the Fatih market in Istanbul, where a tea merchant went throughout the market selling tea in cups to people, some merchants would buy tea for the fixer and me and have it delivered to our "pop-up" photo booth.

In short, our fixer was always the ambassador of the project. Not one disappointed us.

Top row, l-r:
Asma Ajroudi – Doha, Qatar
Djibril Diagne – Dakar, Senegal
Lindeka Qampi – Cape Town, South Africa
Mirna Stankovic – Sarajevo, Bosnia-Herzegovina
Phillipe Ruffat – Paris, France
Susan Candee – Chiang Mai, Thailand

Middle row, l-r:
Than Christie – Mongui, Colombia
Gundem Elci – Istanbul, Turkey
Ewa Podleśna – Warsaw, Poland
Ayneababe Berhanu – Addis Ababa, Ethiopia
Robert Jackson – Oslo, Norway
Luis Galindo – Chimaltenango, Guatemala

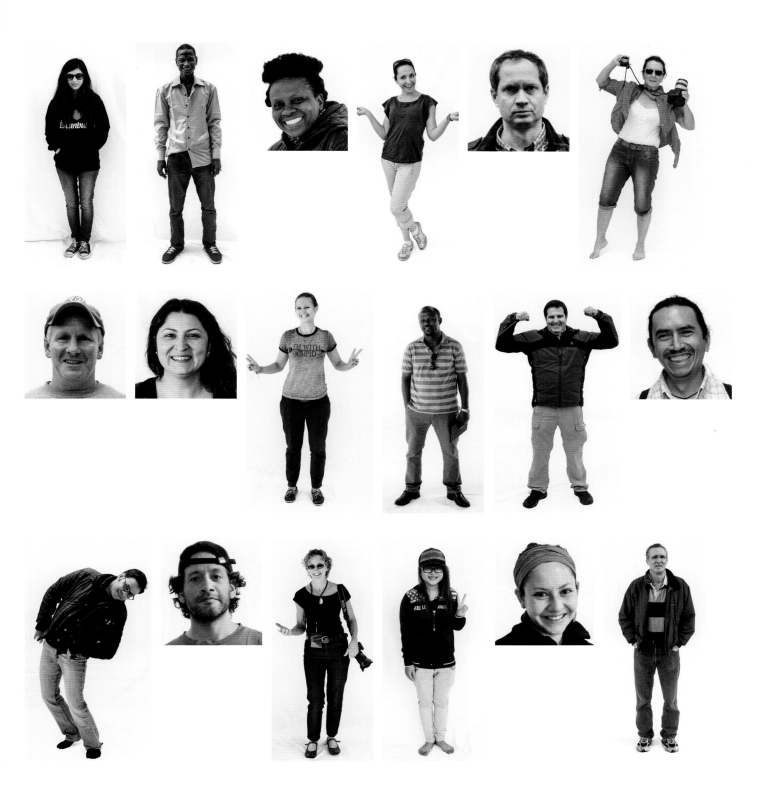

Bottom row, l-r:
Rohit Kumar – Delhi and Pataudi, India
Ji (Jorge) Pena Castillo – Bogata, Colombia
Shannon Wells – Charlottesville, Virginia, USA
Nguyen thi Anh Thu – Longh Tanh, Vietnam
Ana Maria Buitron – Quito and Saquisili, Ecuador
John Gibson – Mebane, North Carolina, USA

Fixers Not Shown:
Anna G. Norton – Chestertown, Martyland. Anna, a talented fine arts photographer and photography educator, was more than a fixer. Periodically during the project she was an important collaborator and source of ideas, and a valuable colleague. I don't know how I managed not to photograph her at least once.

Yuxiang Fang – Shanghai; Yu Su – Beijing
Shatabdi Chakrabarti – Pataudi, India; Nuang – Chiang Mai, Thailand
Zoya Shu, Kiev – Ukraine

Market by Neal Jackson
Copyright © 2018 Neal Jackson and Worldinsight Media

Photographs Copyright © 2018 Neal Jackson
Introduction Copyright © 2018 Neal Jackson
Foreword Copyright © 2018 Maggie Steber

First Edition
Print: ISBN 978-0-692-05287-7
eBook: ISBN 978-0-692-05312-6

Library of Congress Control Number 2018900499

Book design: David Whitmore
Photo editing: Kim Hubbard
Digital editing: Shelby Leeman
Text editing: Amy S. Warner

Published by:
Worldinsight Media
200 Southeast Creek Road
PO Box 9
Church Hill, MD 21623

Printed by: 1010 Printing Group Limited, China

Additional credits:

At critical times wonderful friends around the world
helped the project in ways too numerous to mention.
These, and the locations for which they helped, include:

Anamitra Chakladar – Delhi; Jodi Hilton – Istanbul
Julia Angyal – Budapest; Rukmini Callamachi – Dakar
Jacqueline de Ladonchamps – Vendôme
John Edwin Mason – Cape Town
Diana My Tran – Longh Tanh
Adriana Zehbrauskas – Quito
Susan Bastress – Doha; Hongxia Liu – Beijing
Hugh Stevens – Mebane, North Carolina, USA

I'm sure I've missed some people who deserve mention –
there were so many. My sincerest apologies to them.